Tyrannosaurus Rex (T-Rex): A Journey into the Prehistoric Era - Awesome Dinosaurs

Target Audience: Coloring Book for All Ages

Unleash Your Inner Artist with Amazing Dinosaur Animals: A Coloring Book for All Ages!

Dive into a world of prehistoric wonder with Amazing Dinosaur Animals: Coloring Book for All Ages. This relaxing coloring book features a stunning collection of dinosaur designs, perfect for anyone who loves these magnificent creatures.

Escape the Ordinary and Embrace Tranquility:

Hand-drawn illustrations in a calming style allow you to de-stress and unwind, leaving the everyday worries behind.

Originality at Its Finest:

Each dinosaur image is meticulously hand-drawn, ensuring a unique and creative coloring experience.

Unparalleled Quality:

Over 50 intricate and detailed dinosaur models provide endless hours of coloring fun.

Embrace Diversity:

Every page offers a new and exciting dinosaur to bring to life with vibrant colors.

Single-Sided Pages, Double the Fun:

No bleed-through means you can use your favorite coloring tools without worry.

More Than Just Coloring:

Relaxing with this book isn't just about coloring; it's about unlocking your creativity, boosting self-esteem, and building confidence.

The Perfect Gift:

This coloring book makes a fantastic gift for dinosaur enthusiasts, art lovers, and anyone who needs a moment of peace and relaxation.

Book Specifications:

Premium Softcover Binding

50 Unique Dinosaur Coloring Pages

Unleash your inner artist and explore the world of dinosaurs with Amazing Dinosaur Animals: Coloring Book for All Ages!

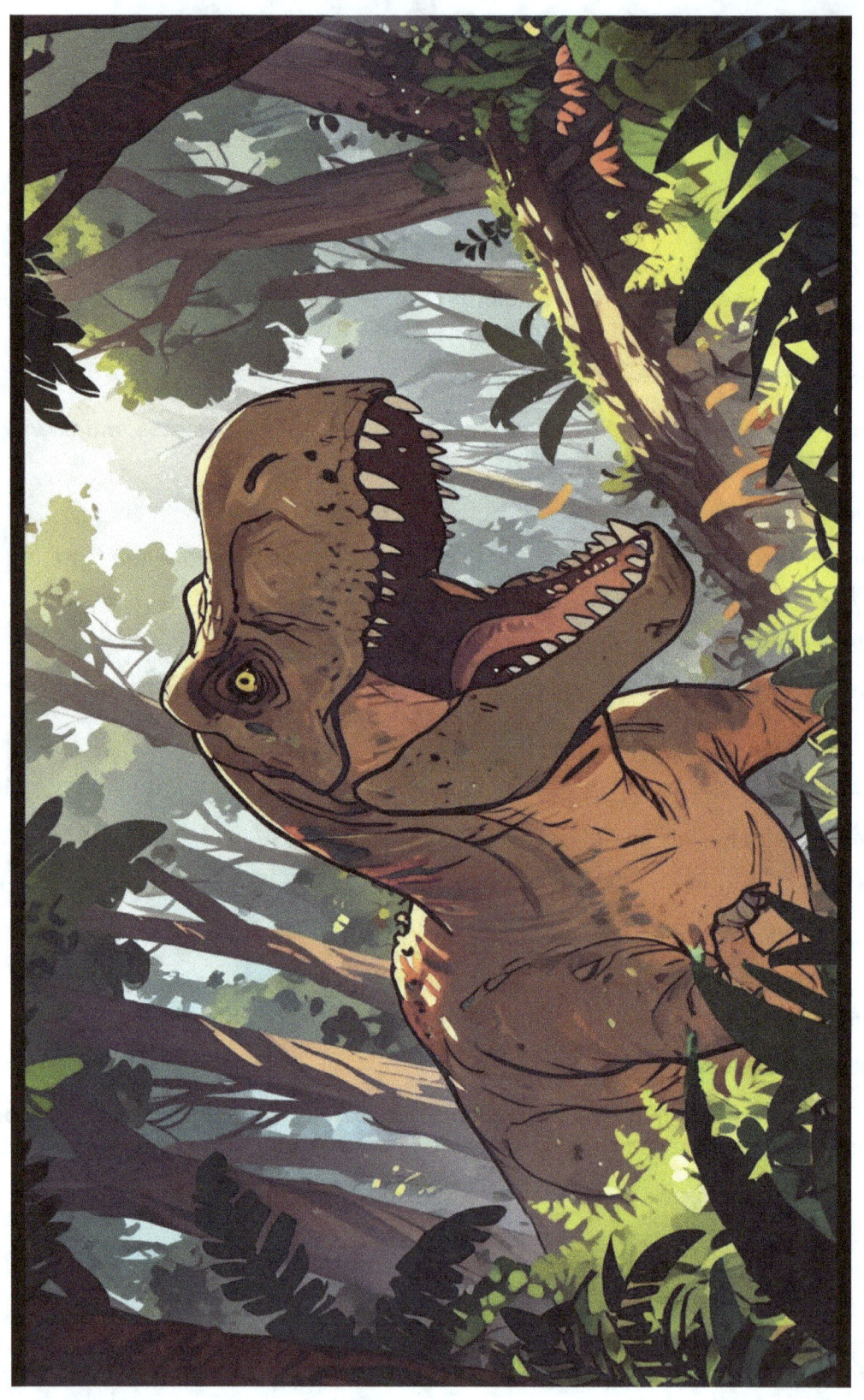

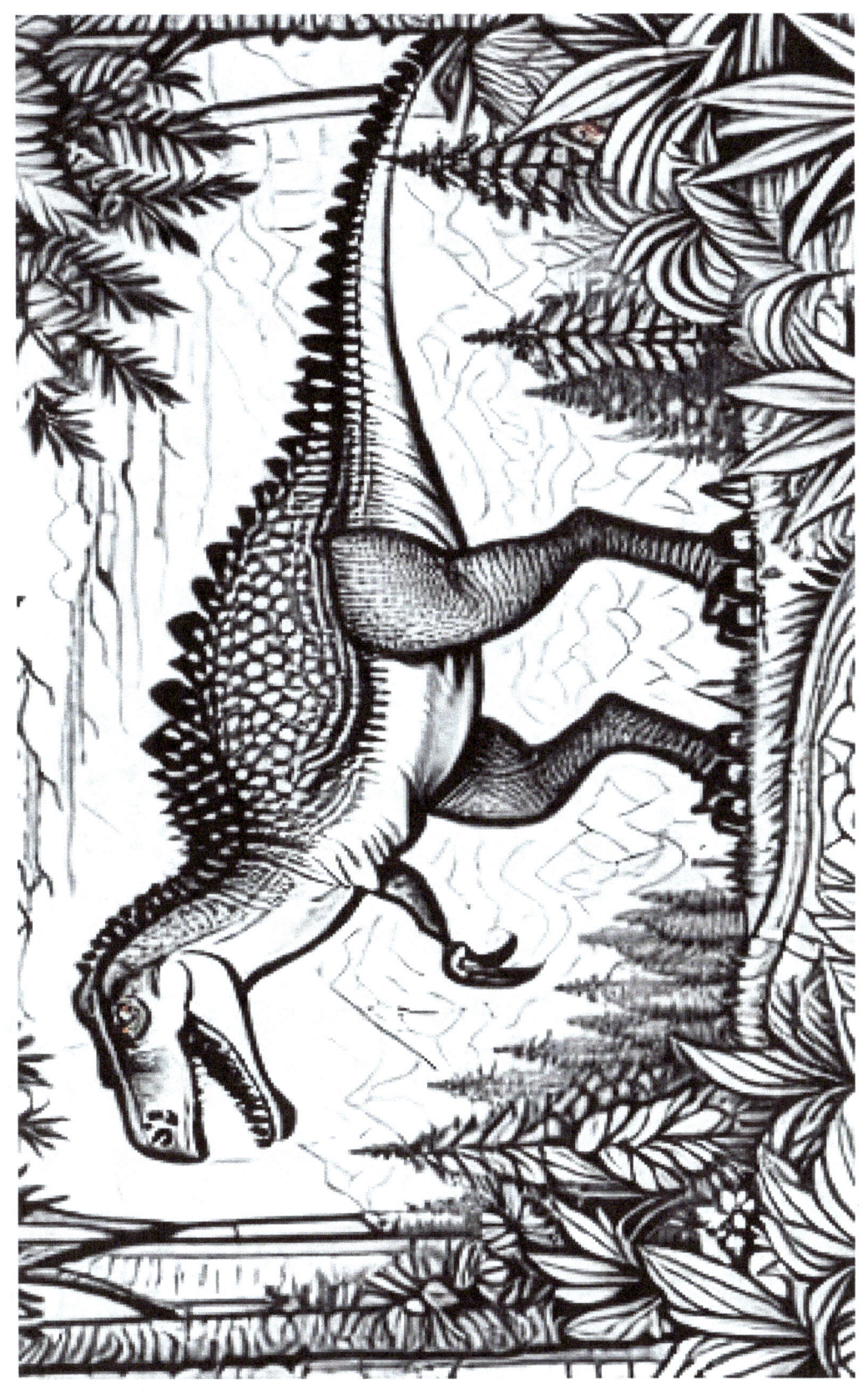

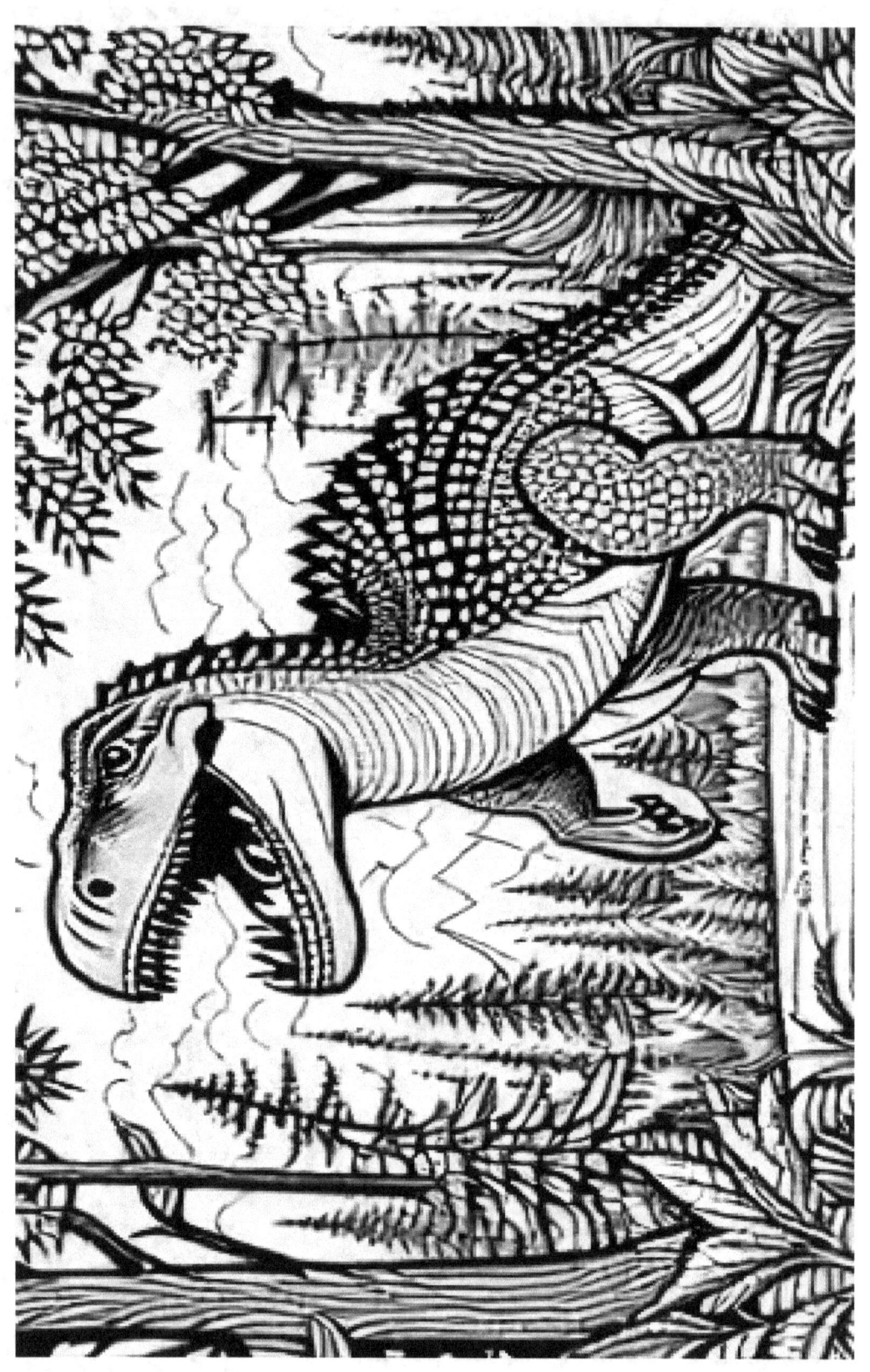

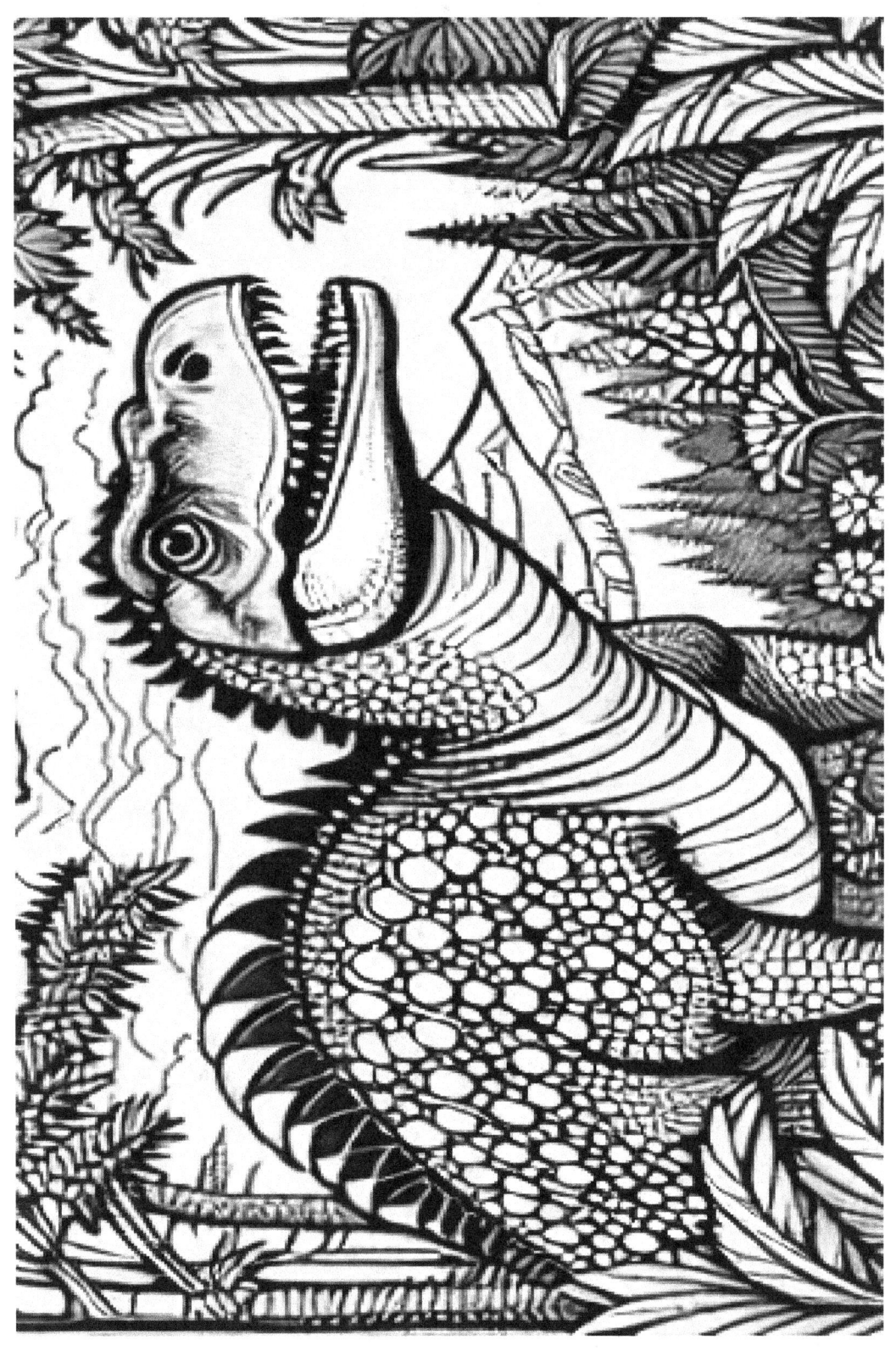

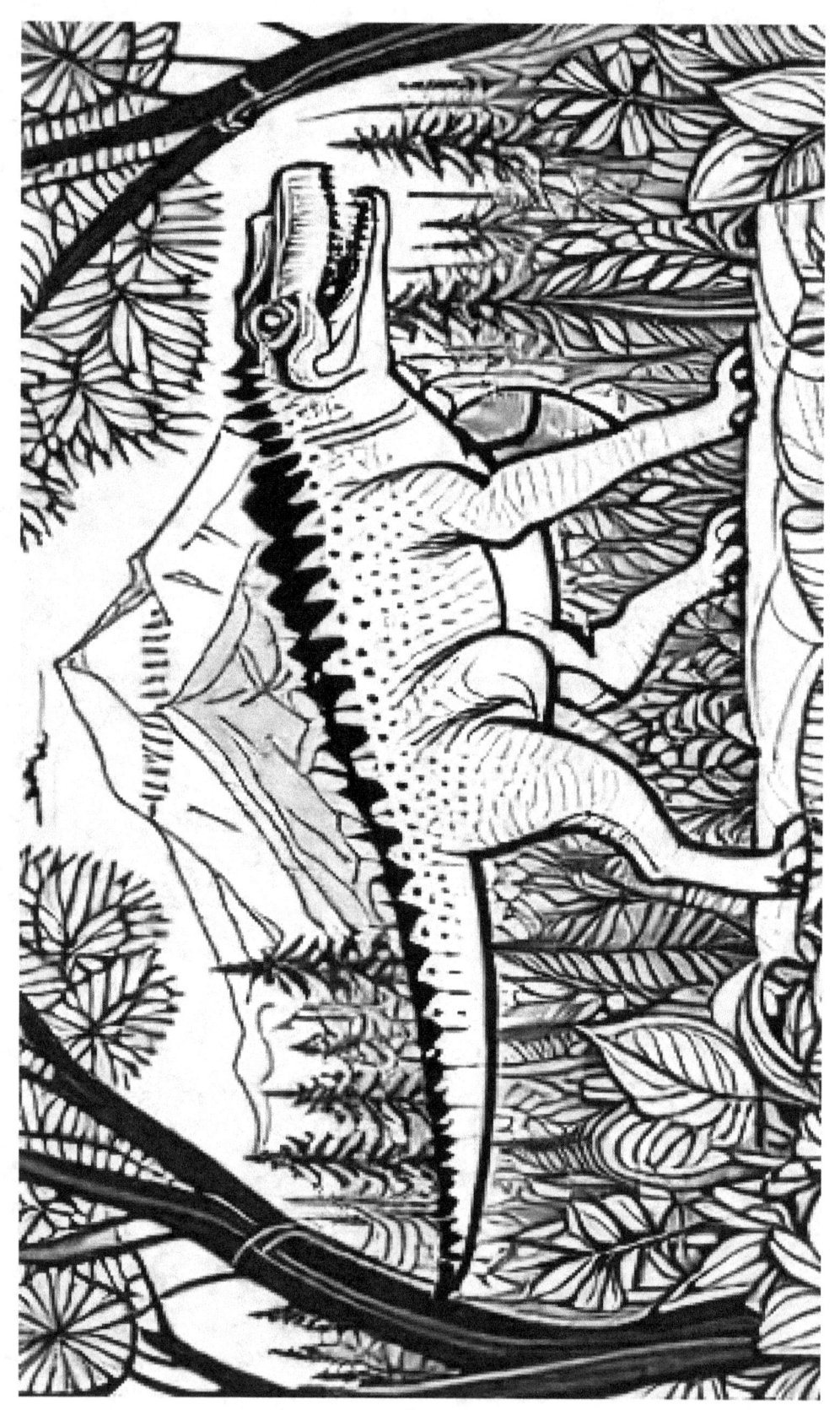

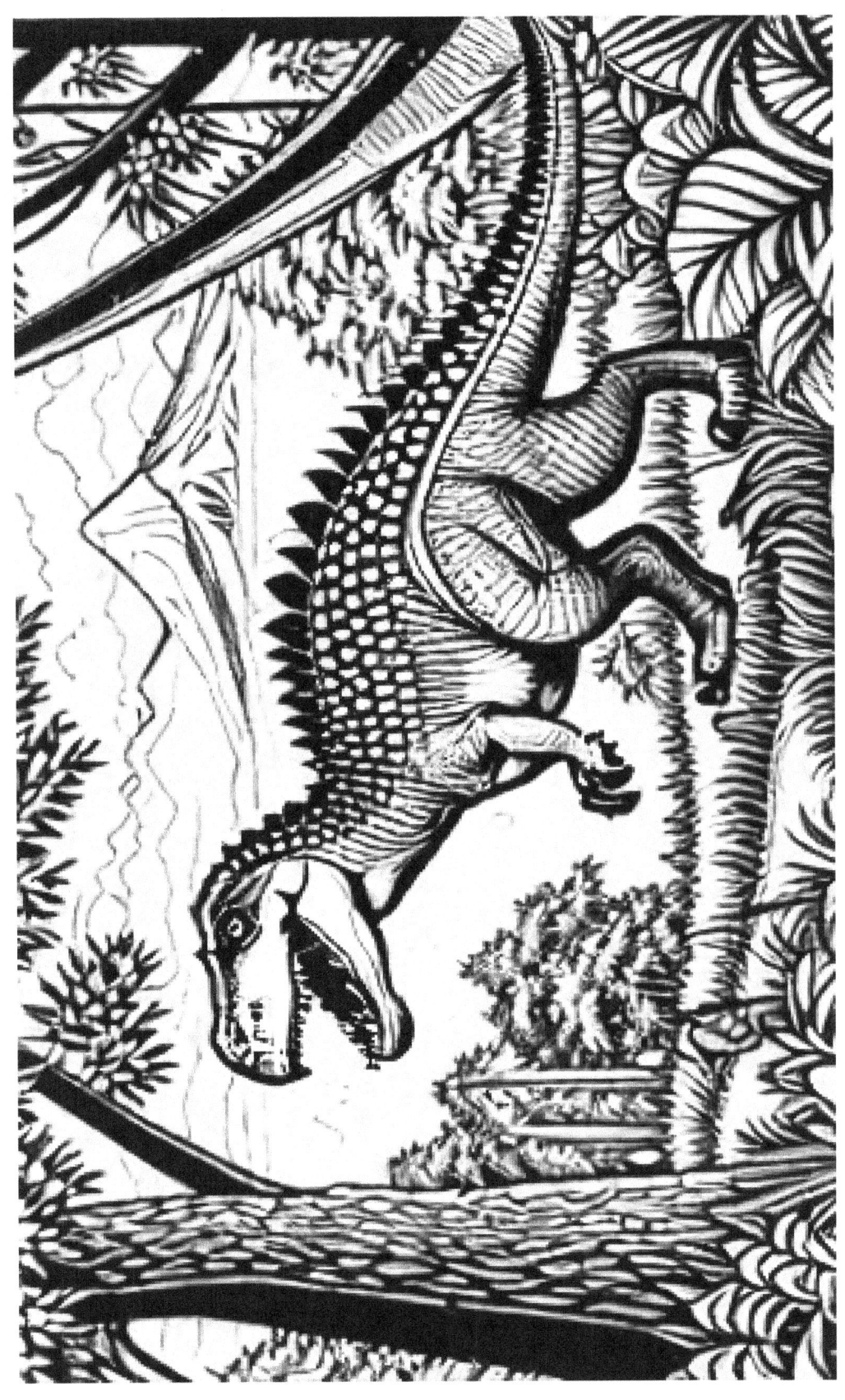

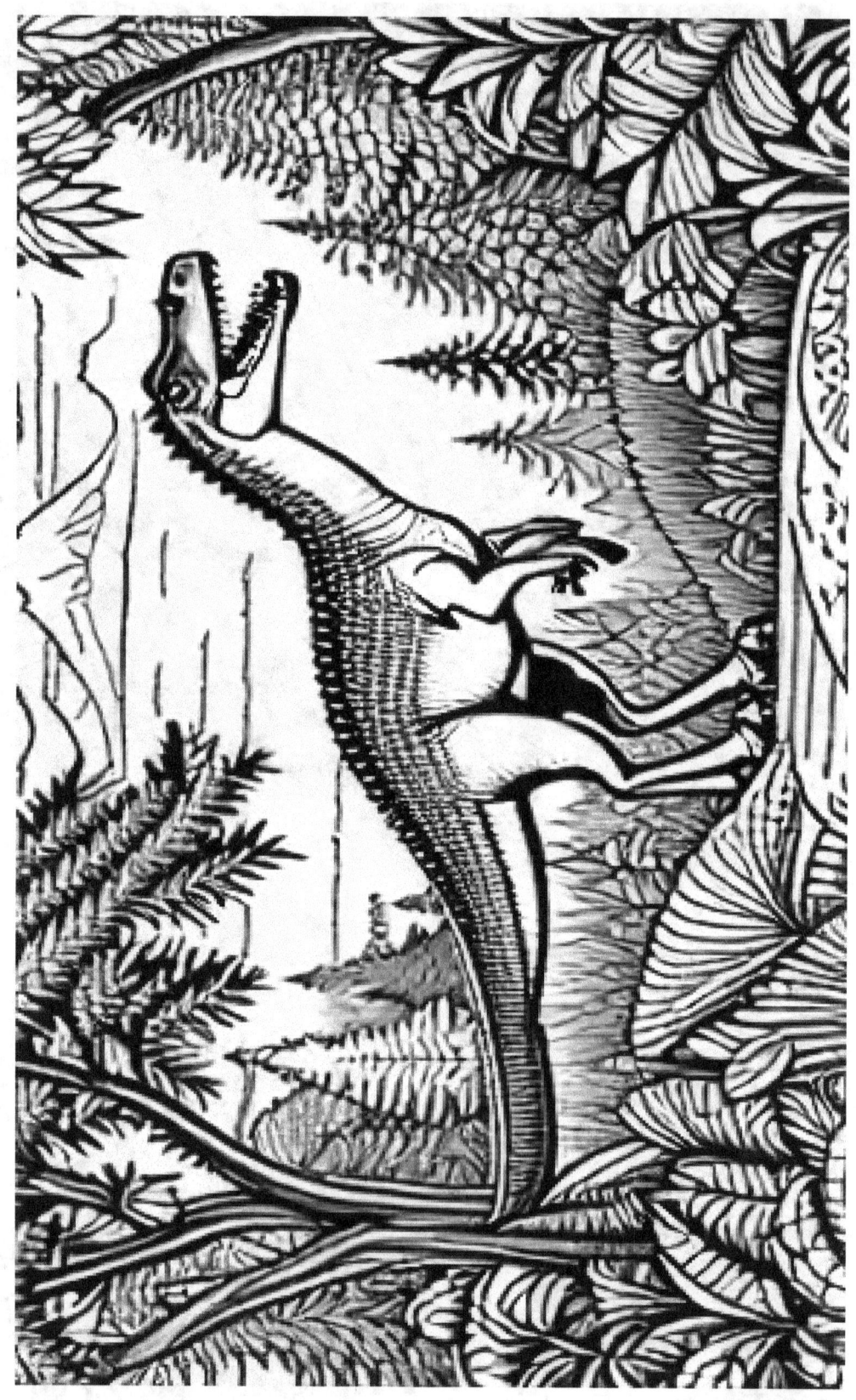

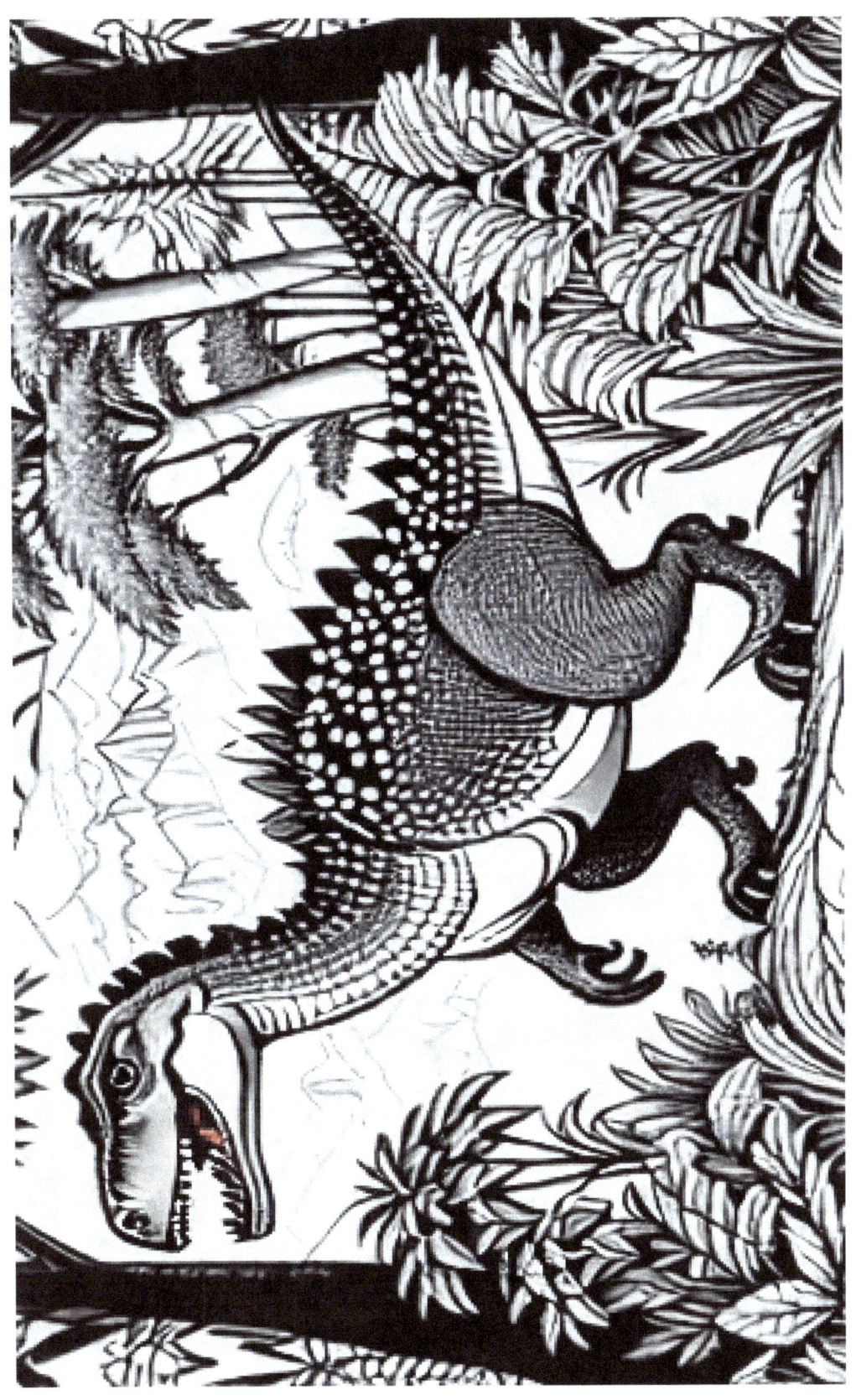

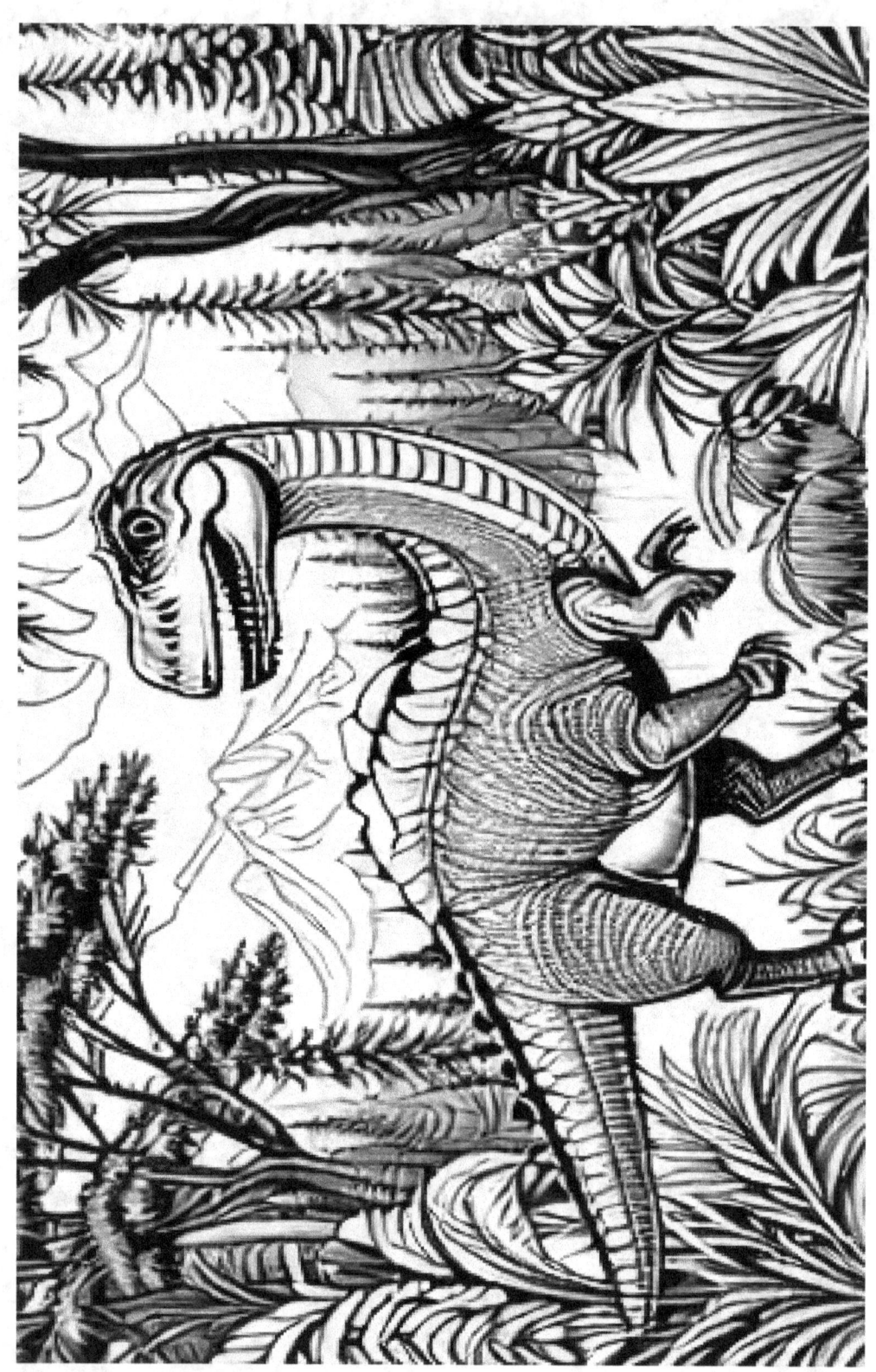

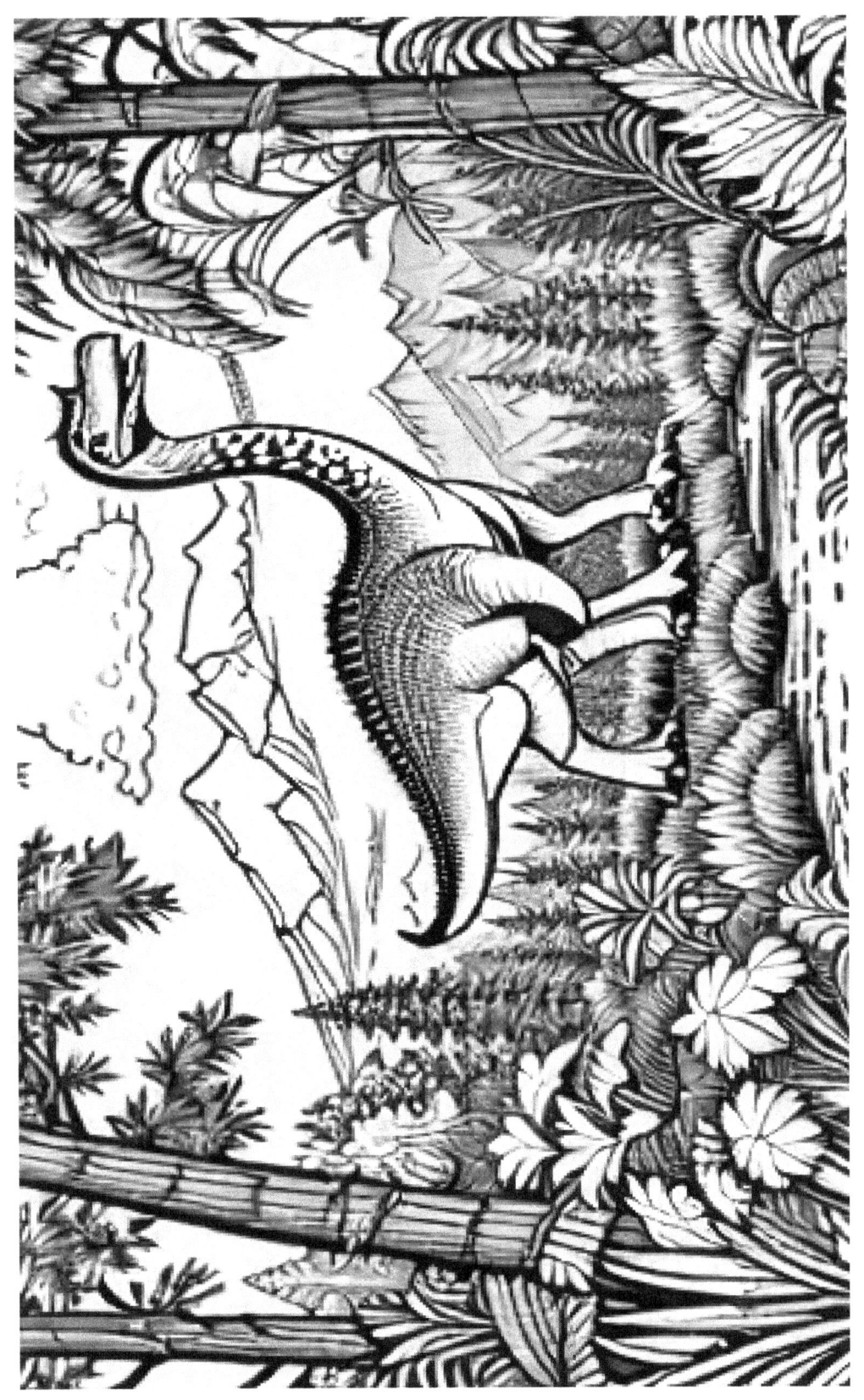

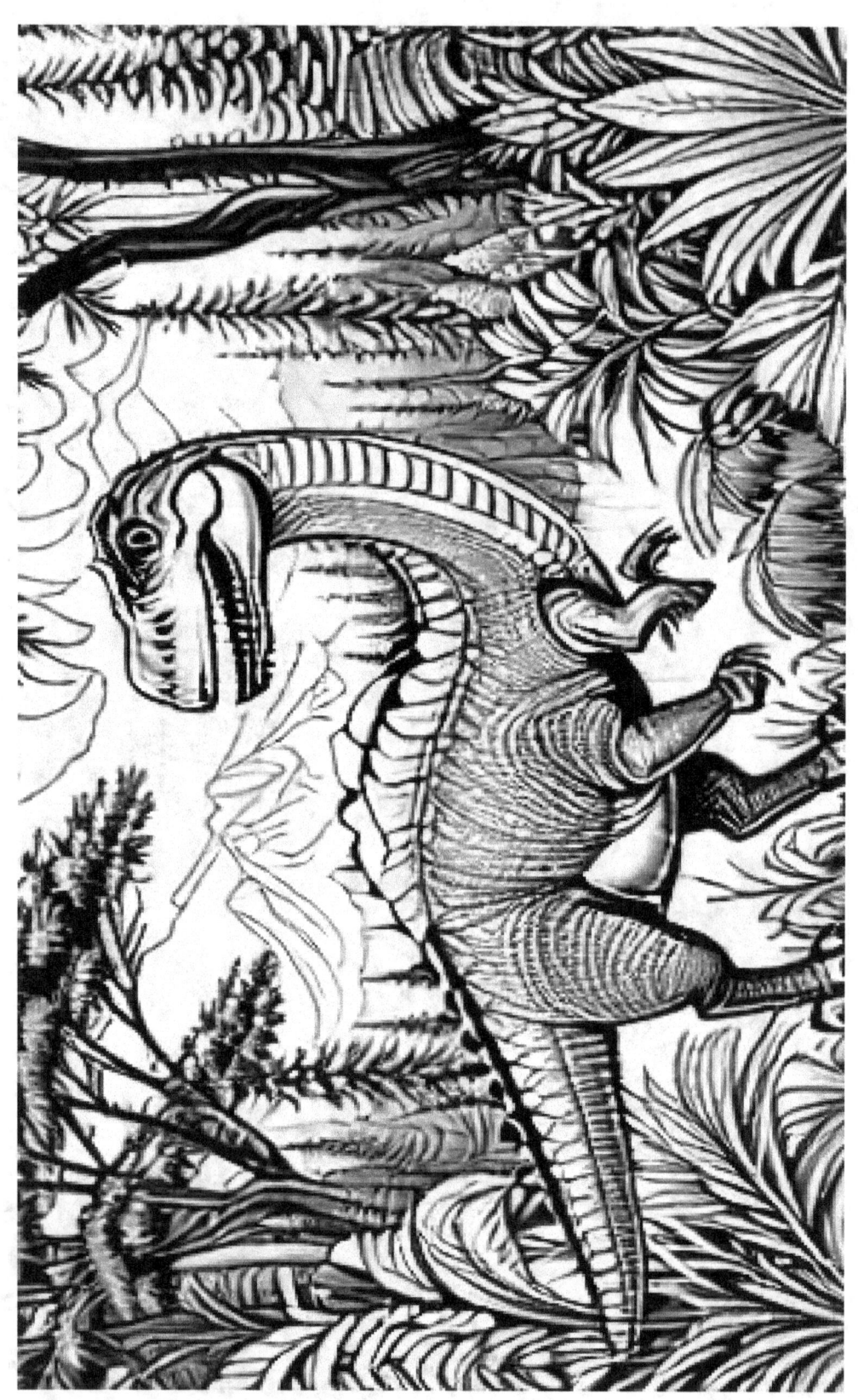

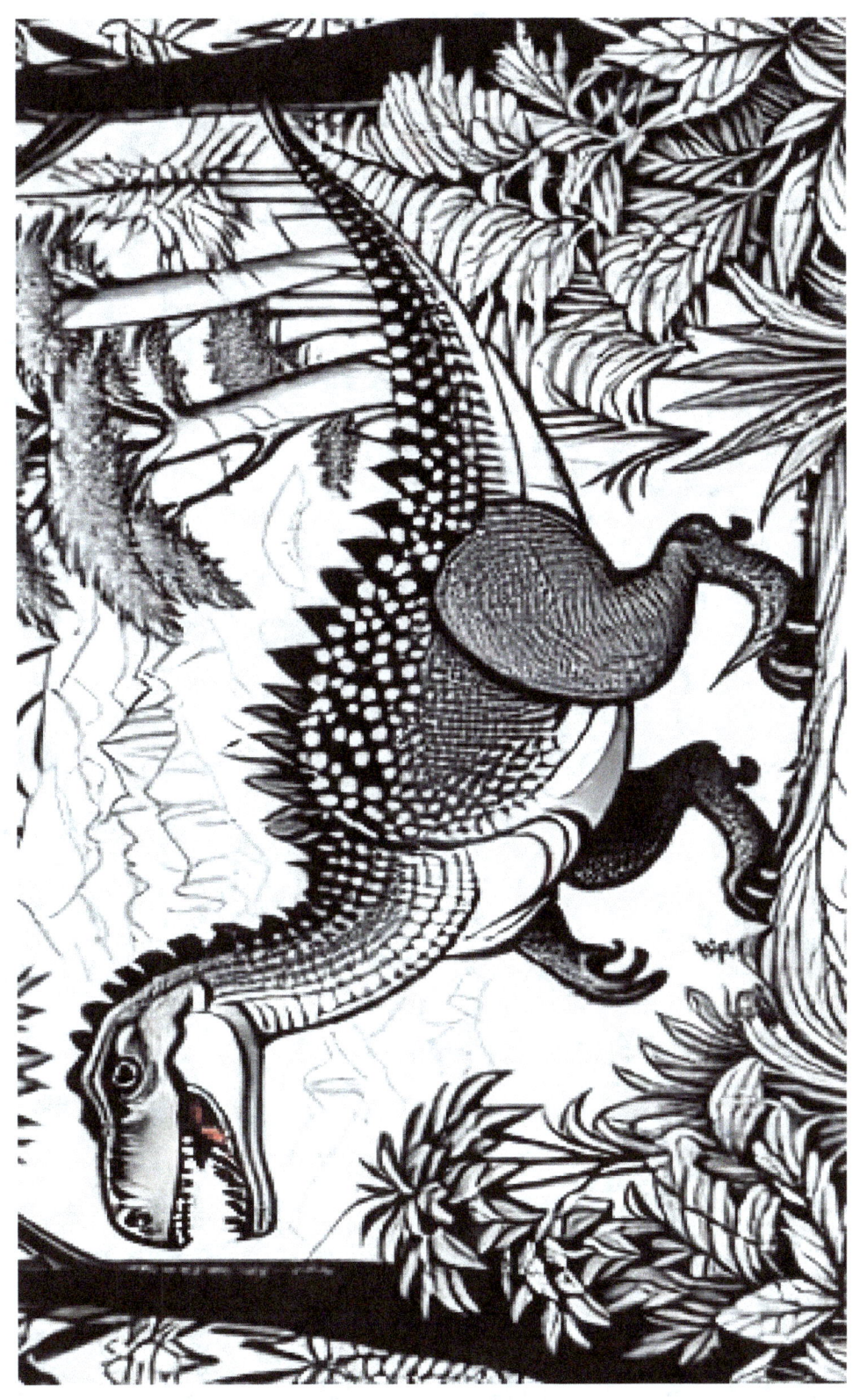

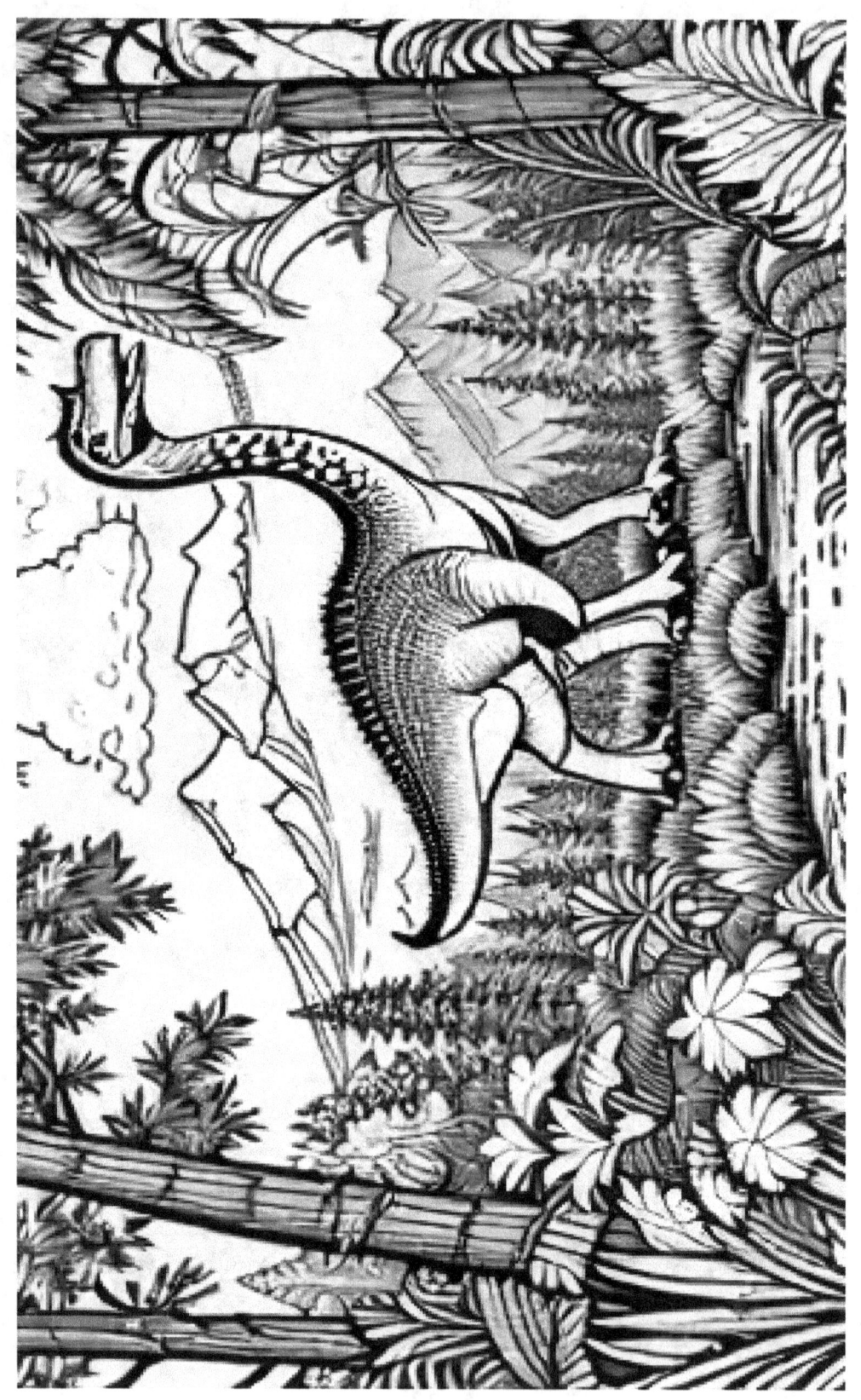

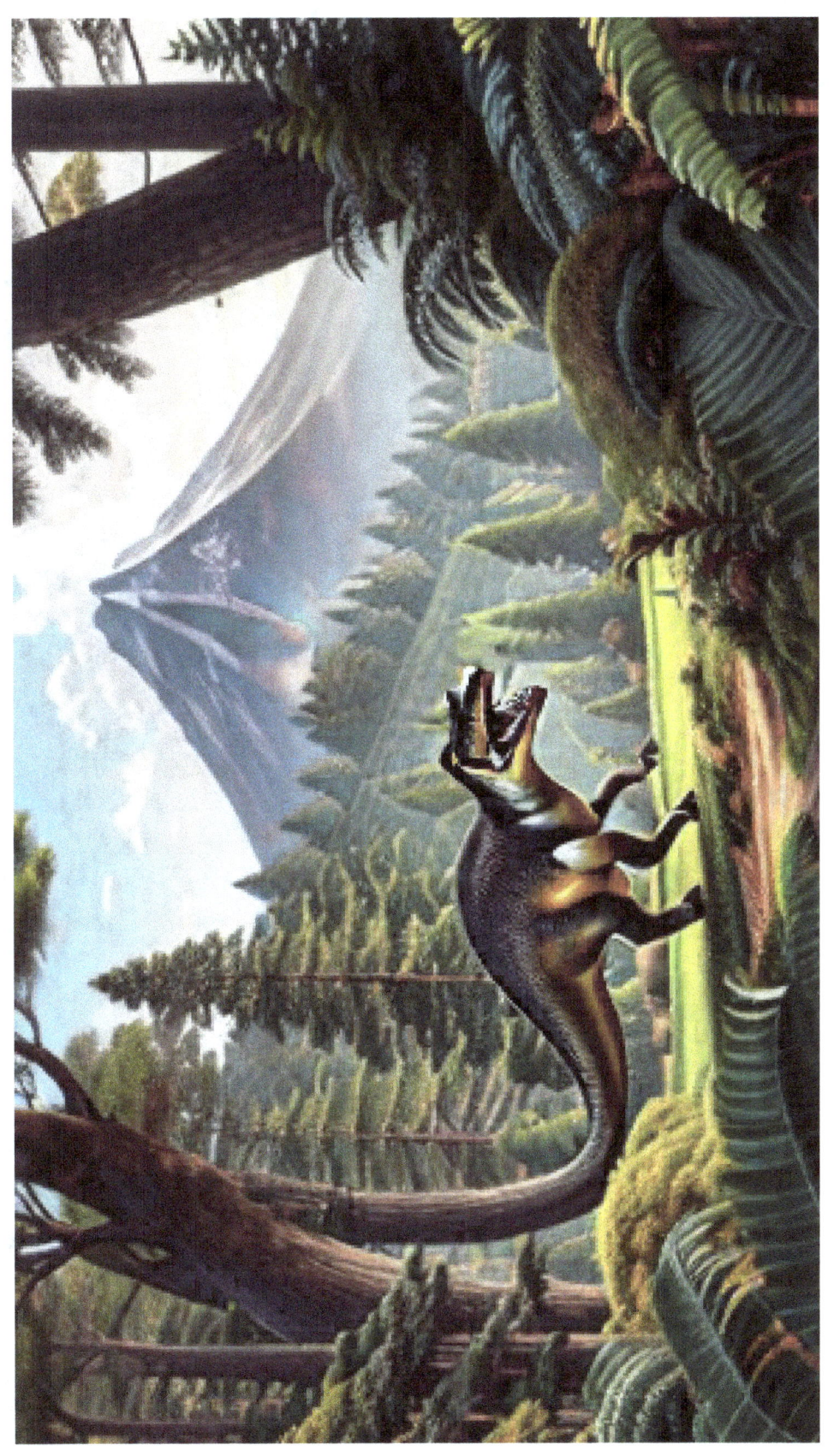

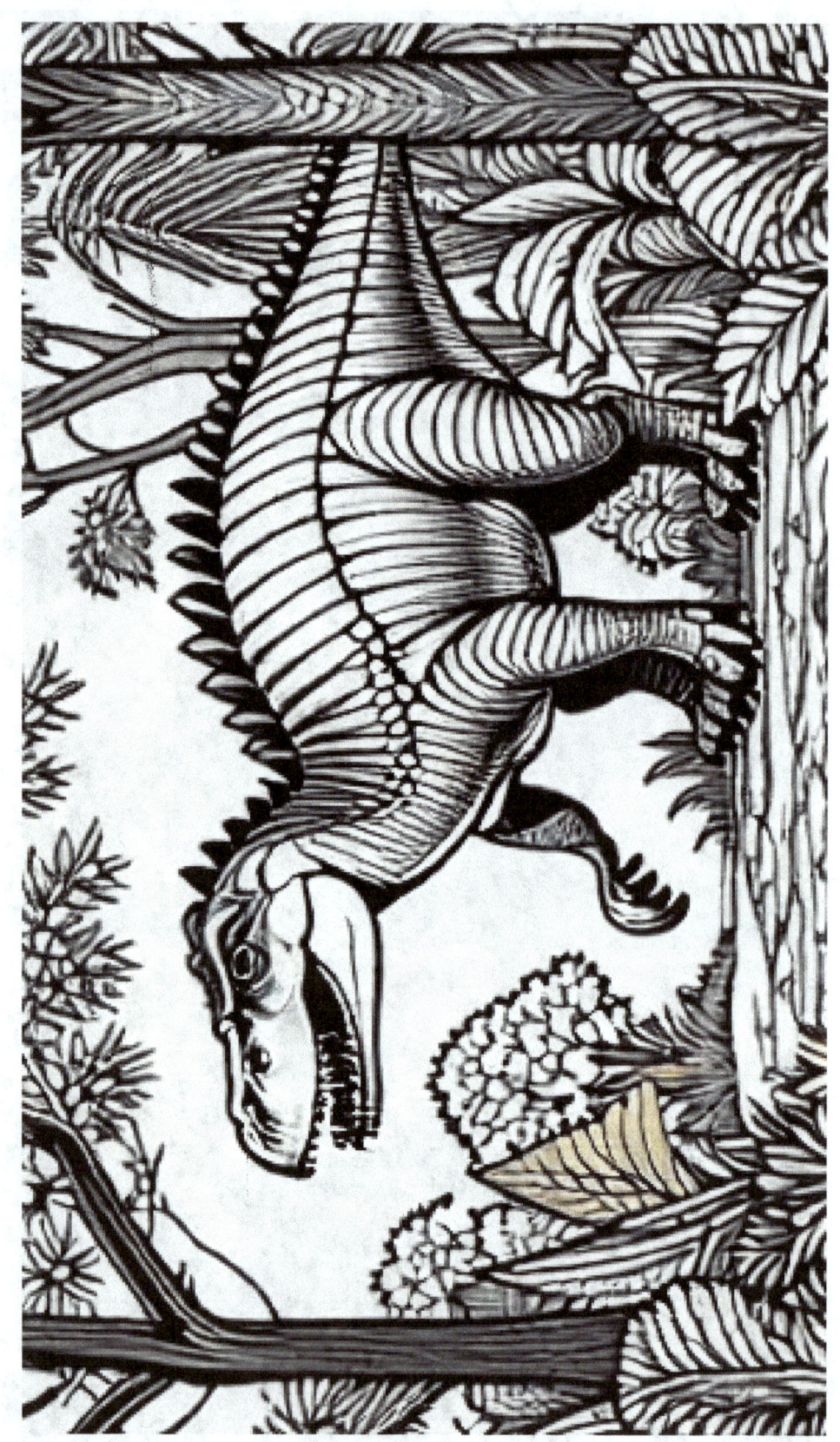

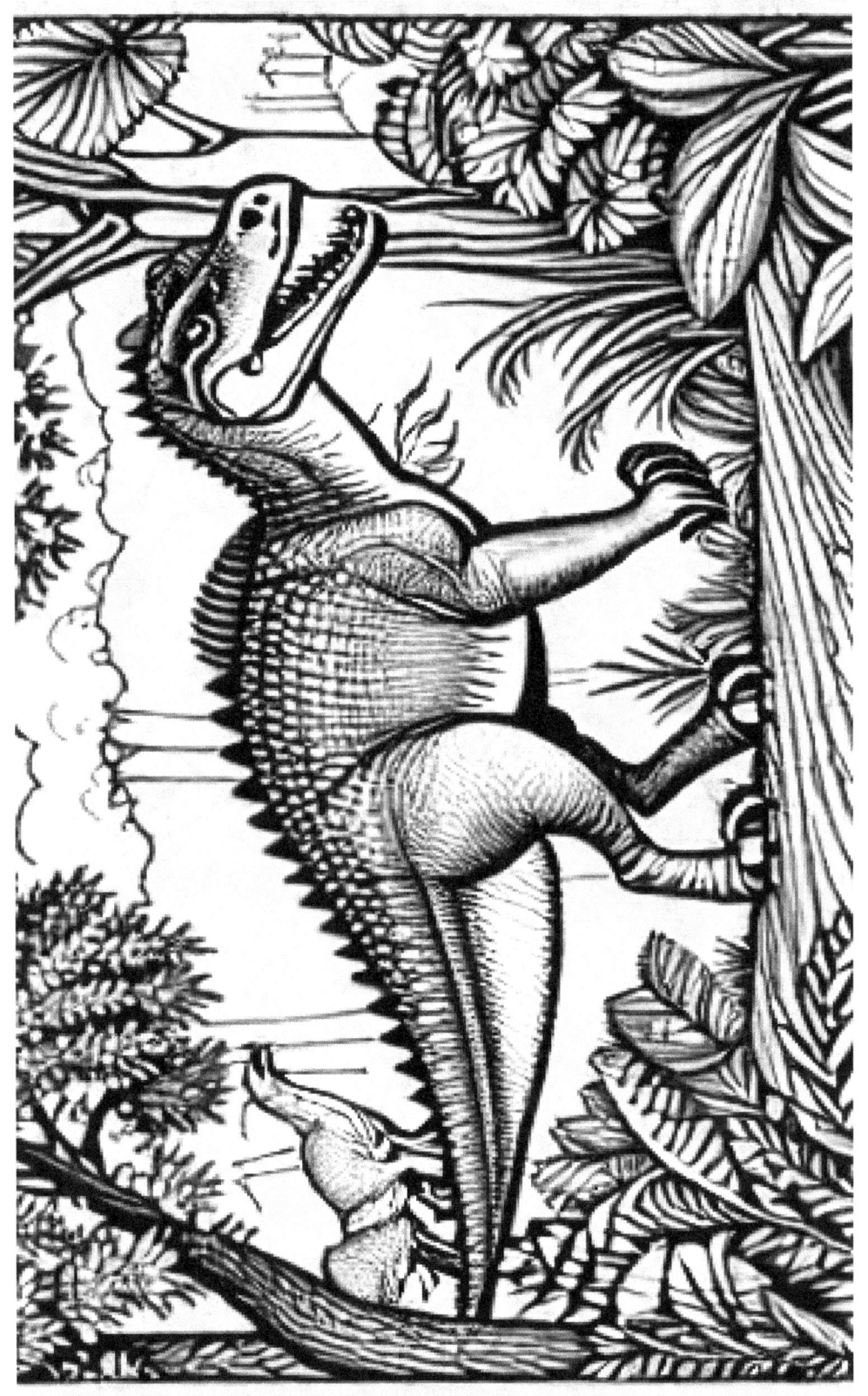

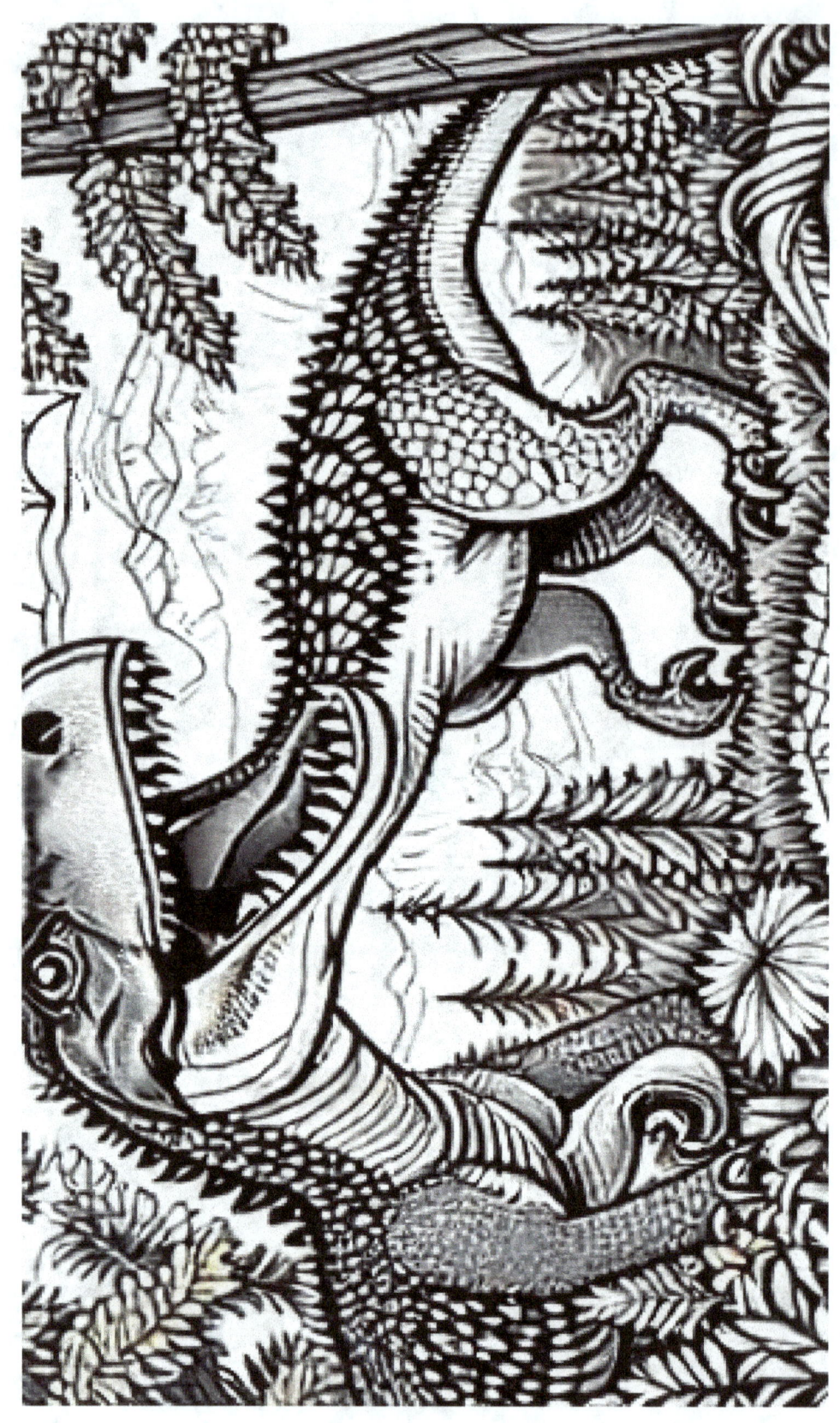

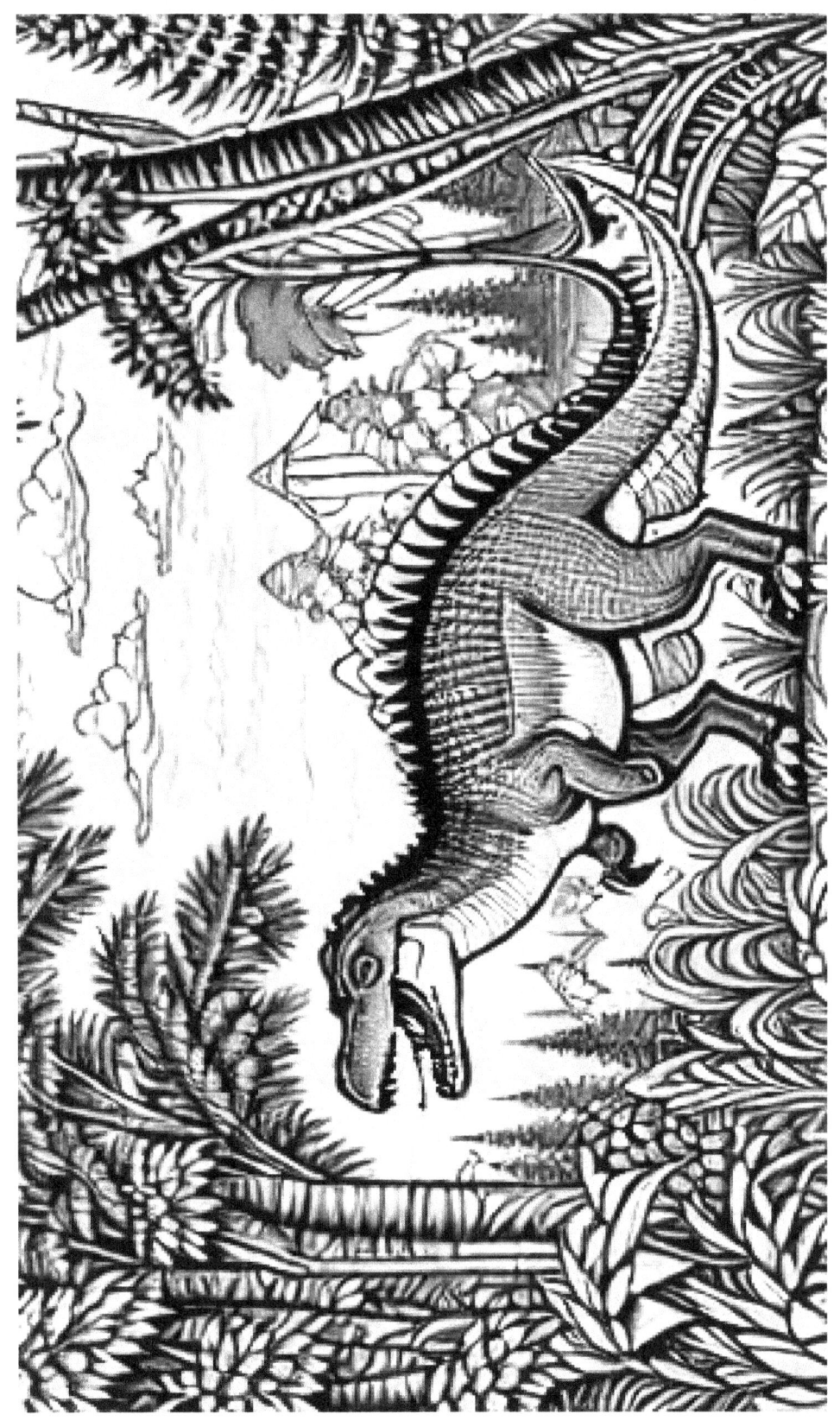

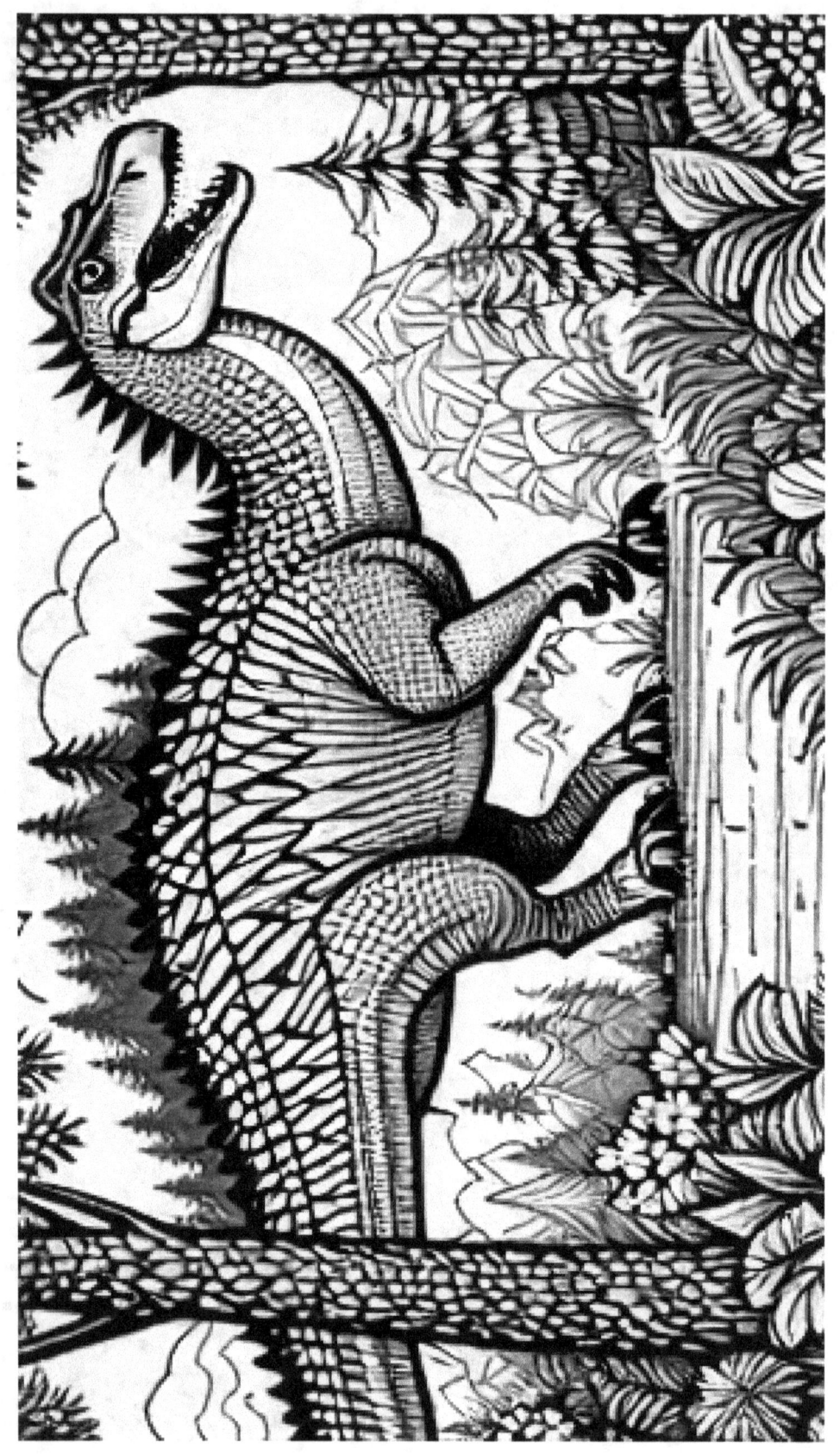

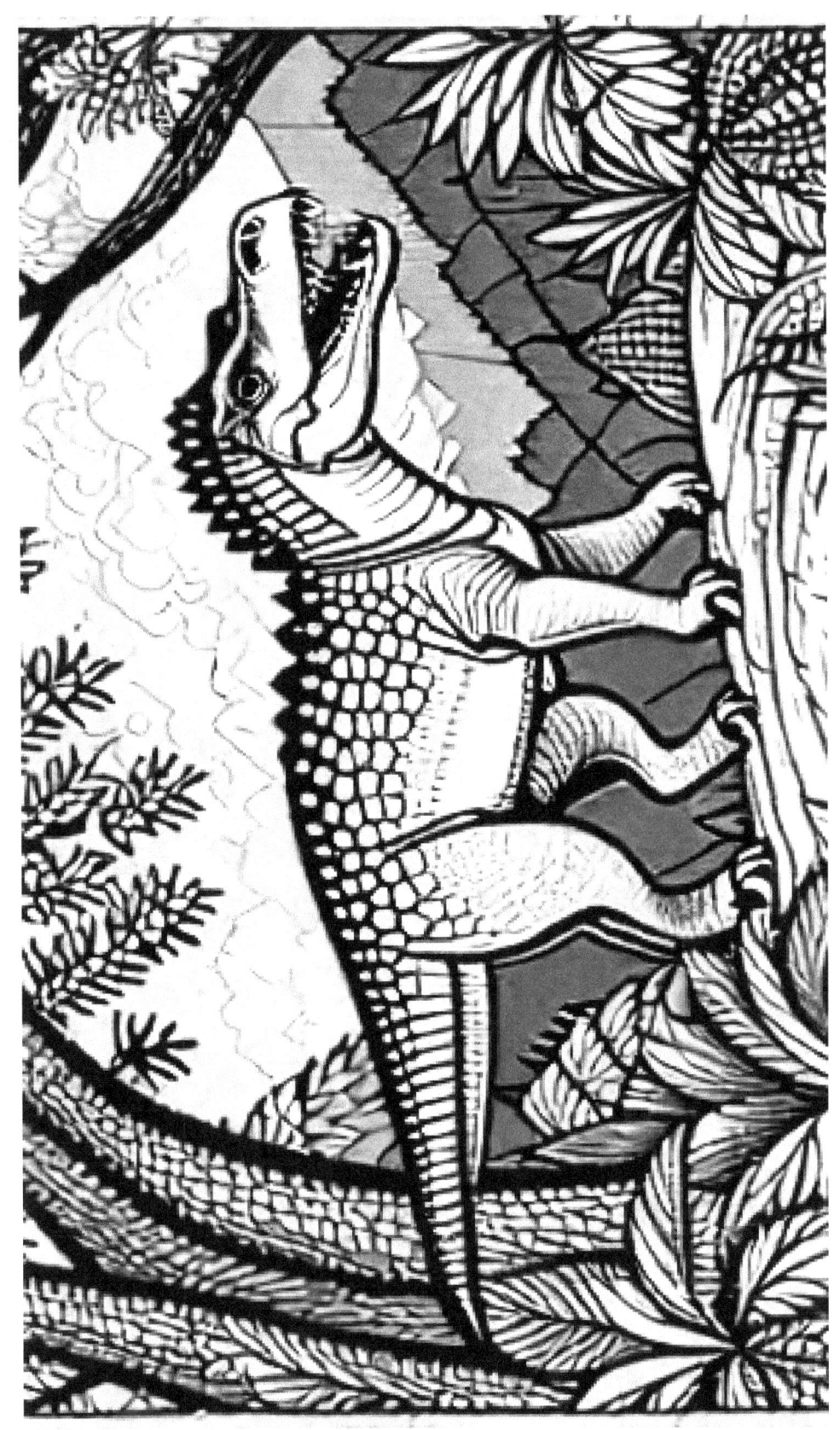

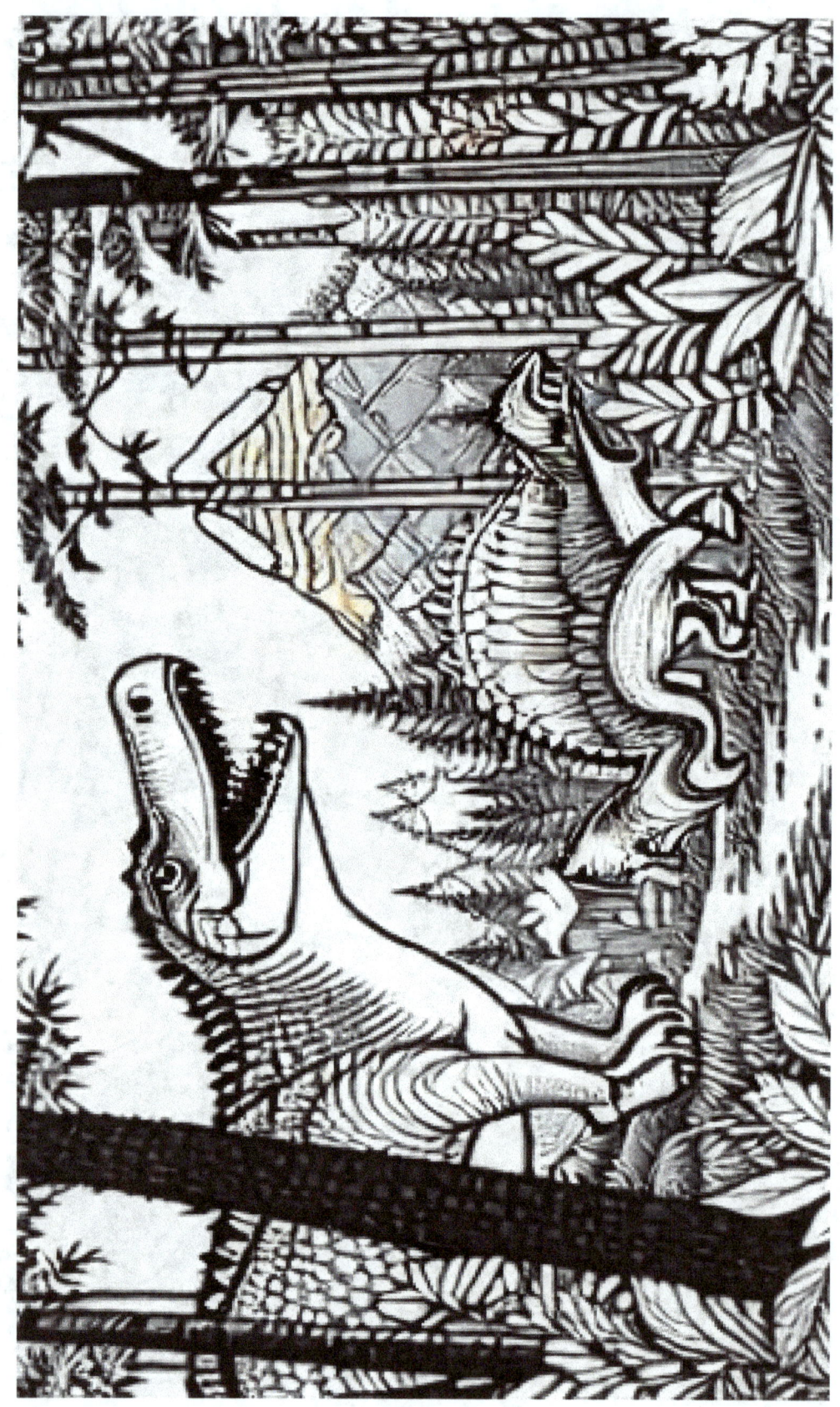

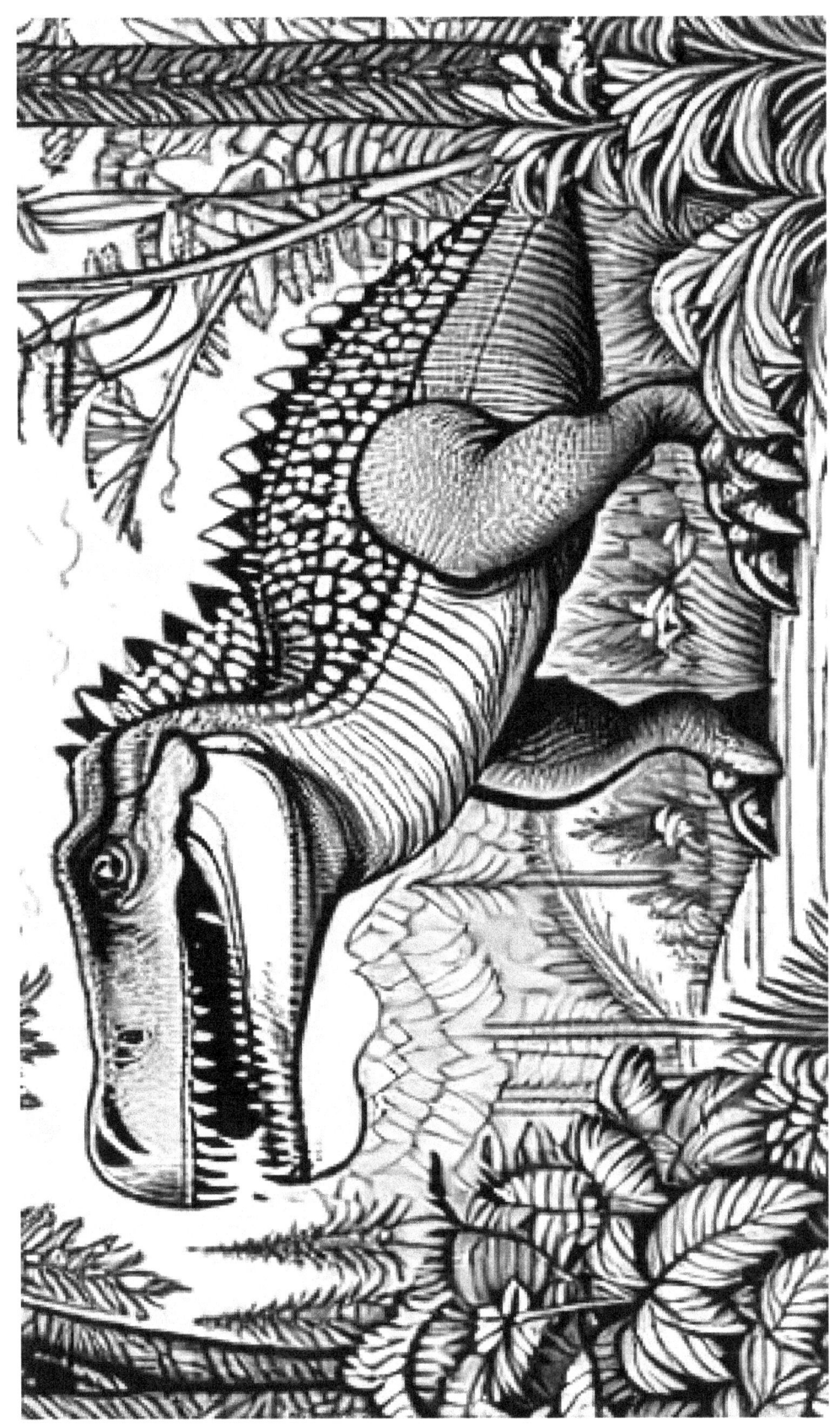

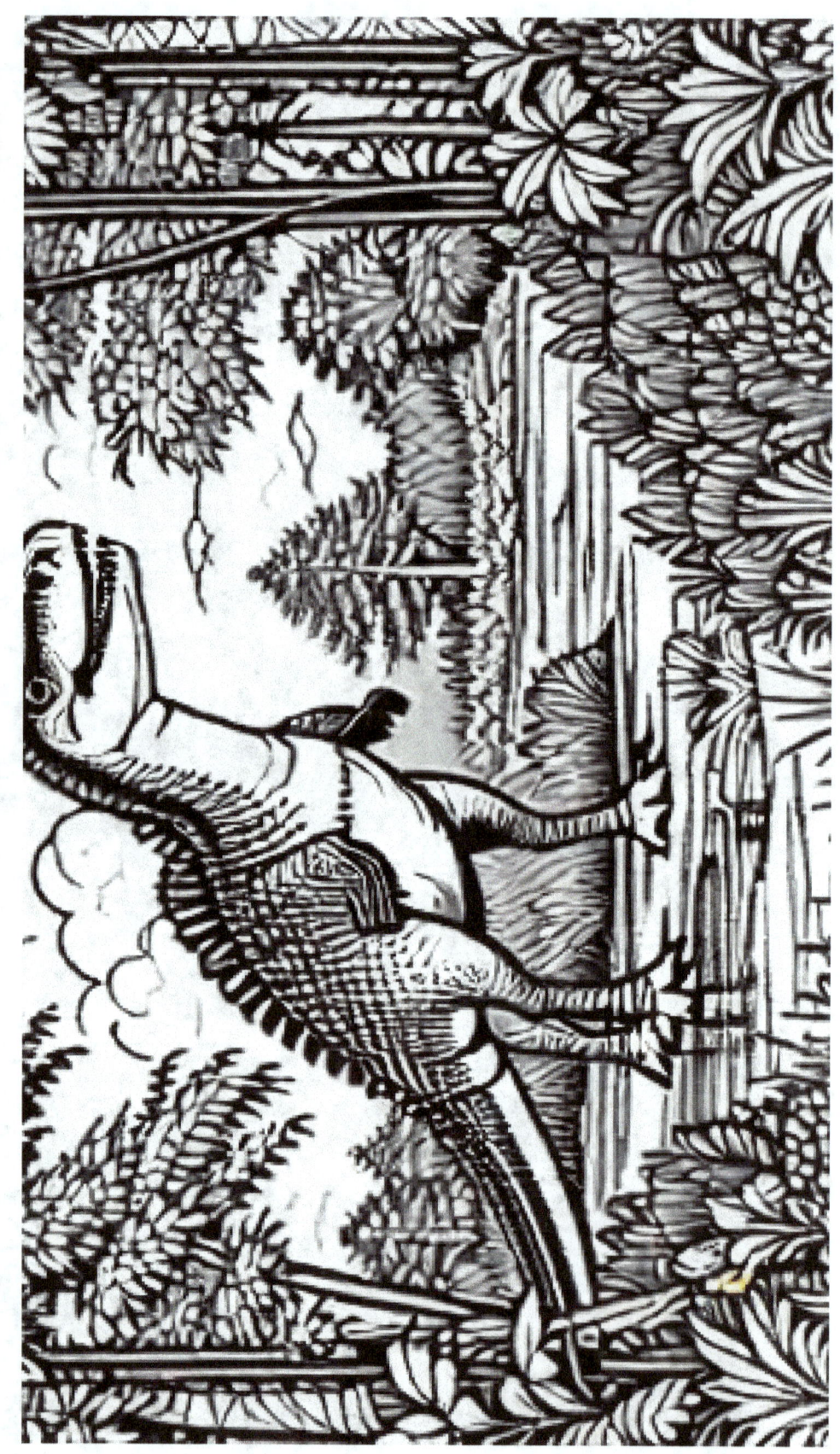

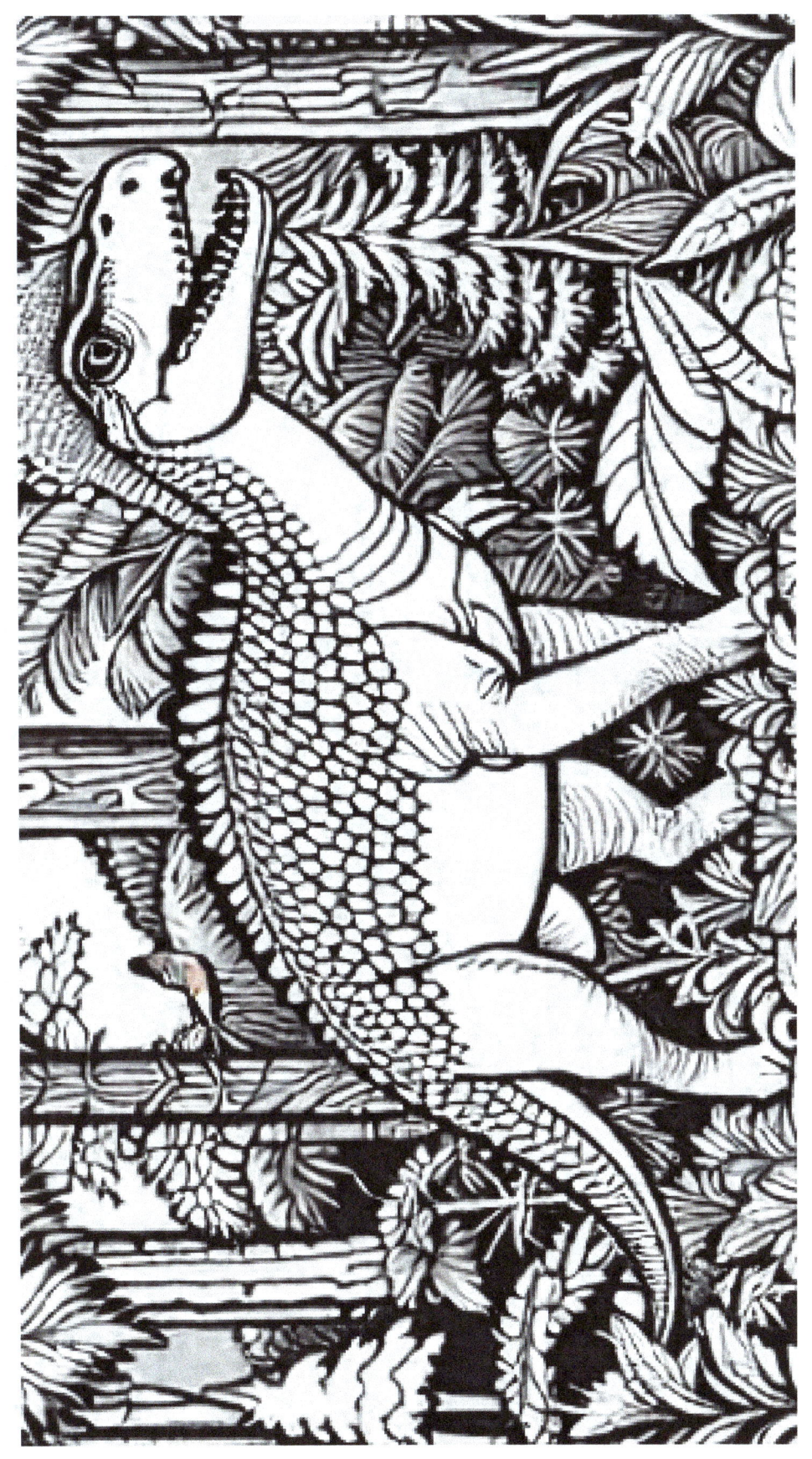

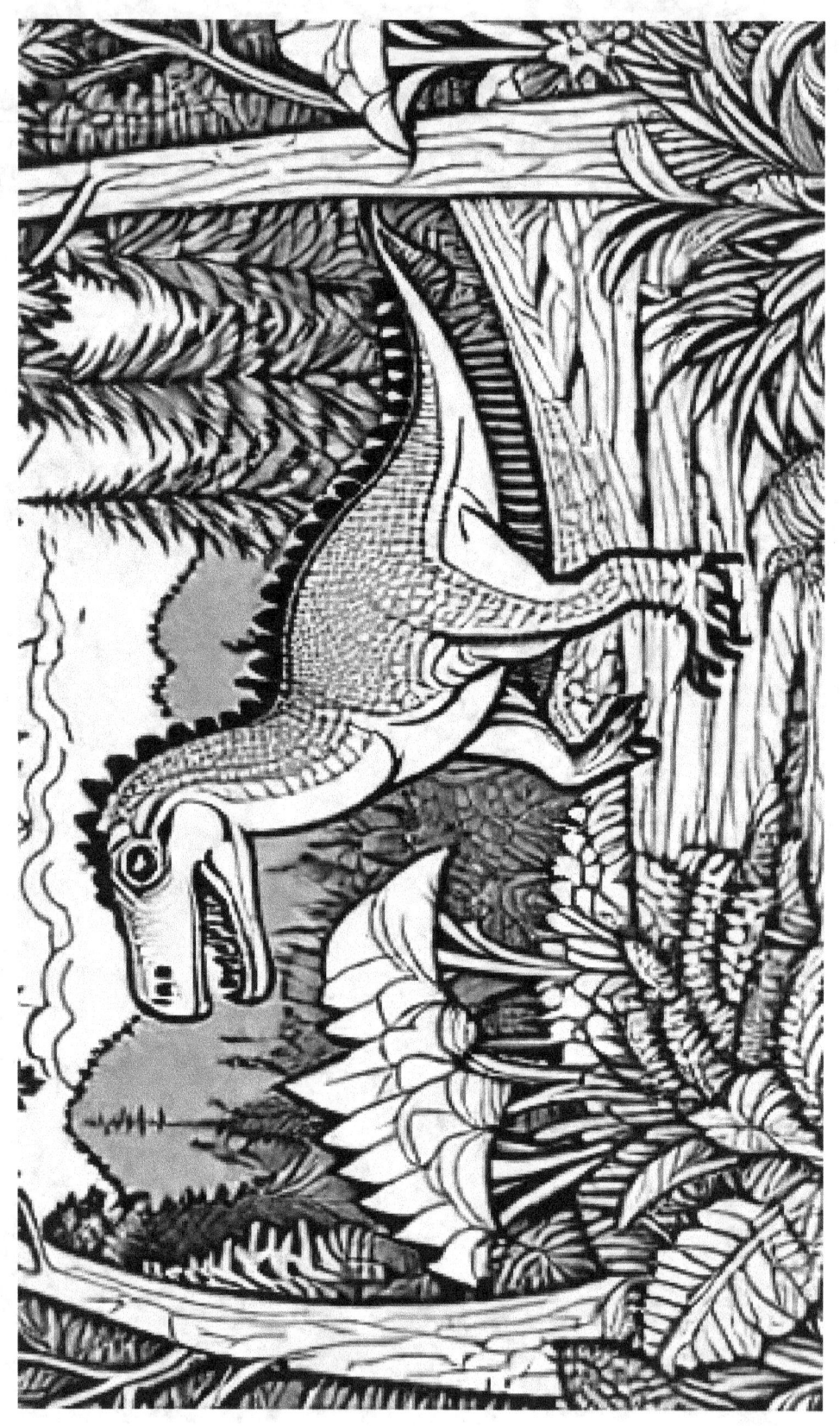

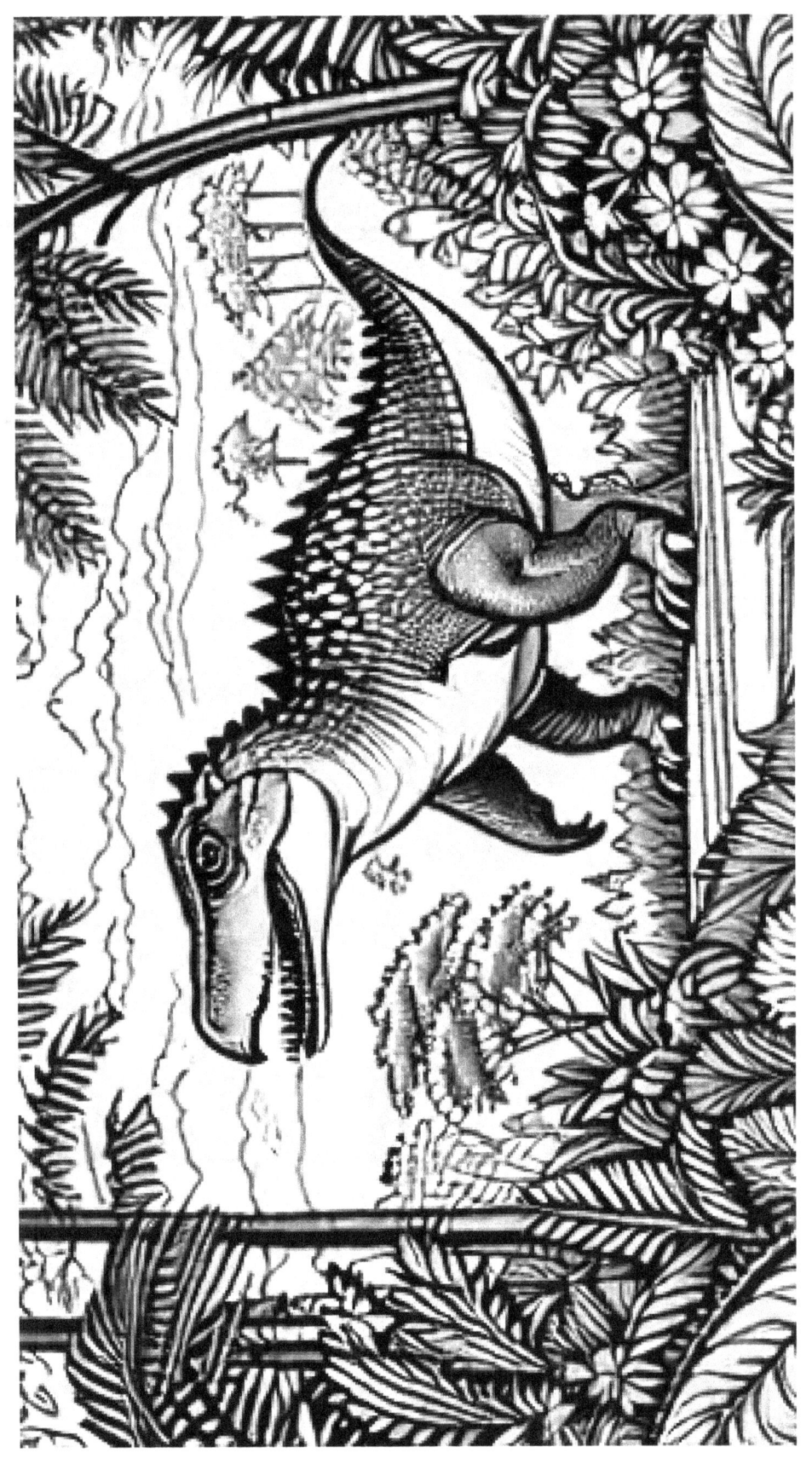

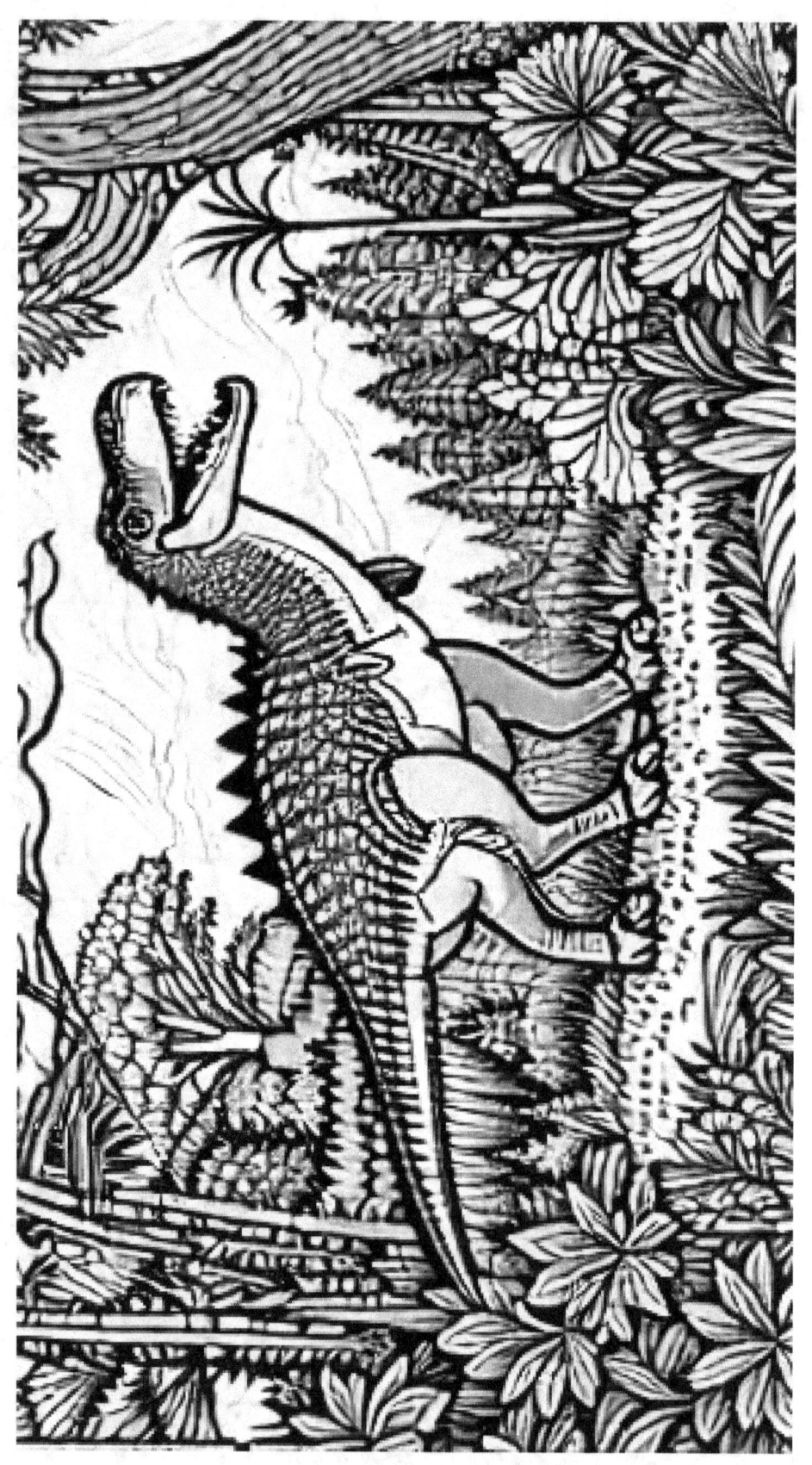

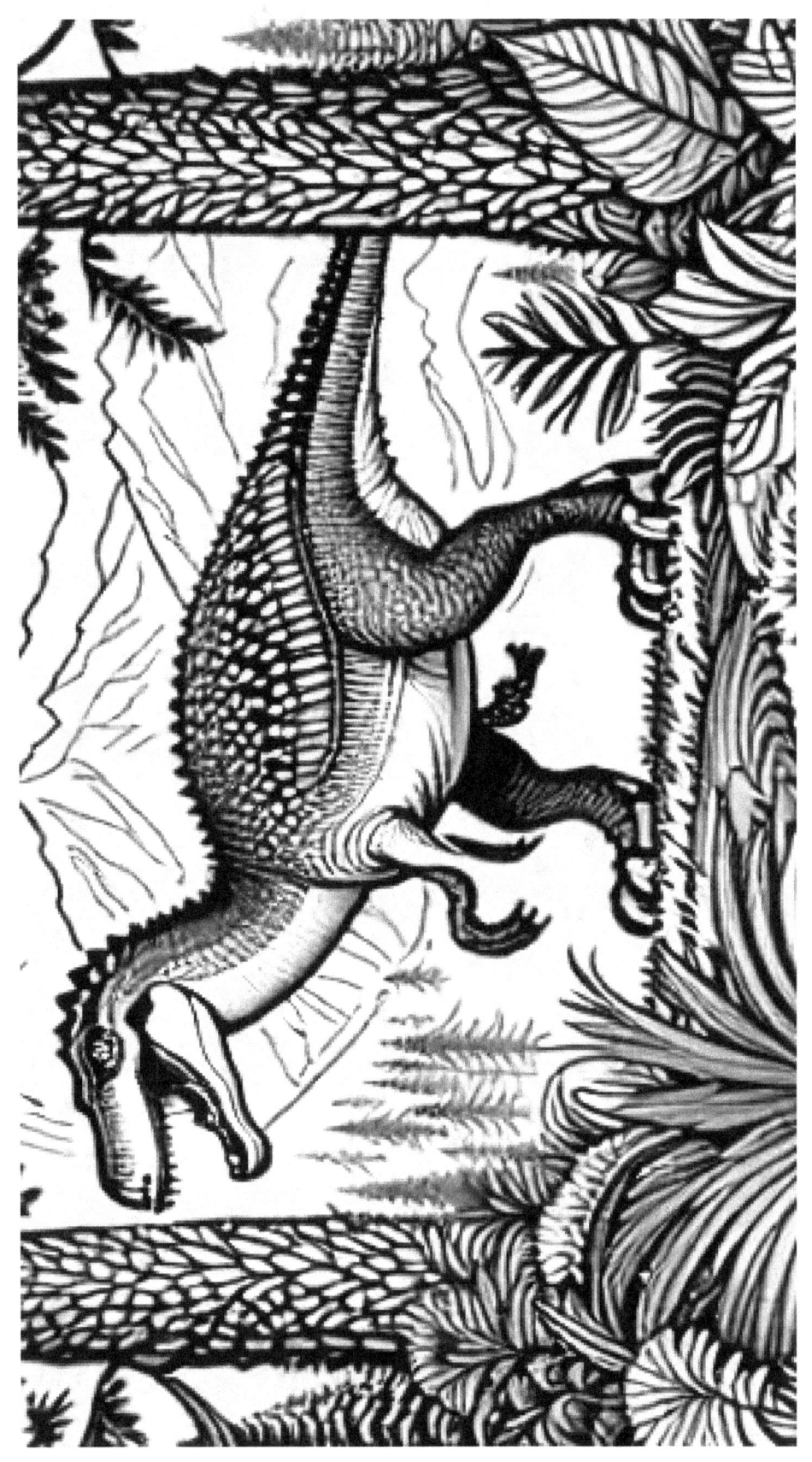

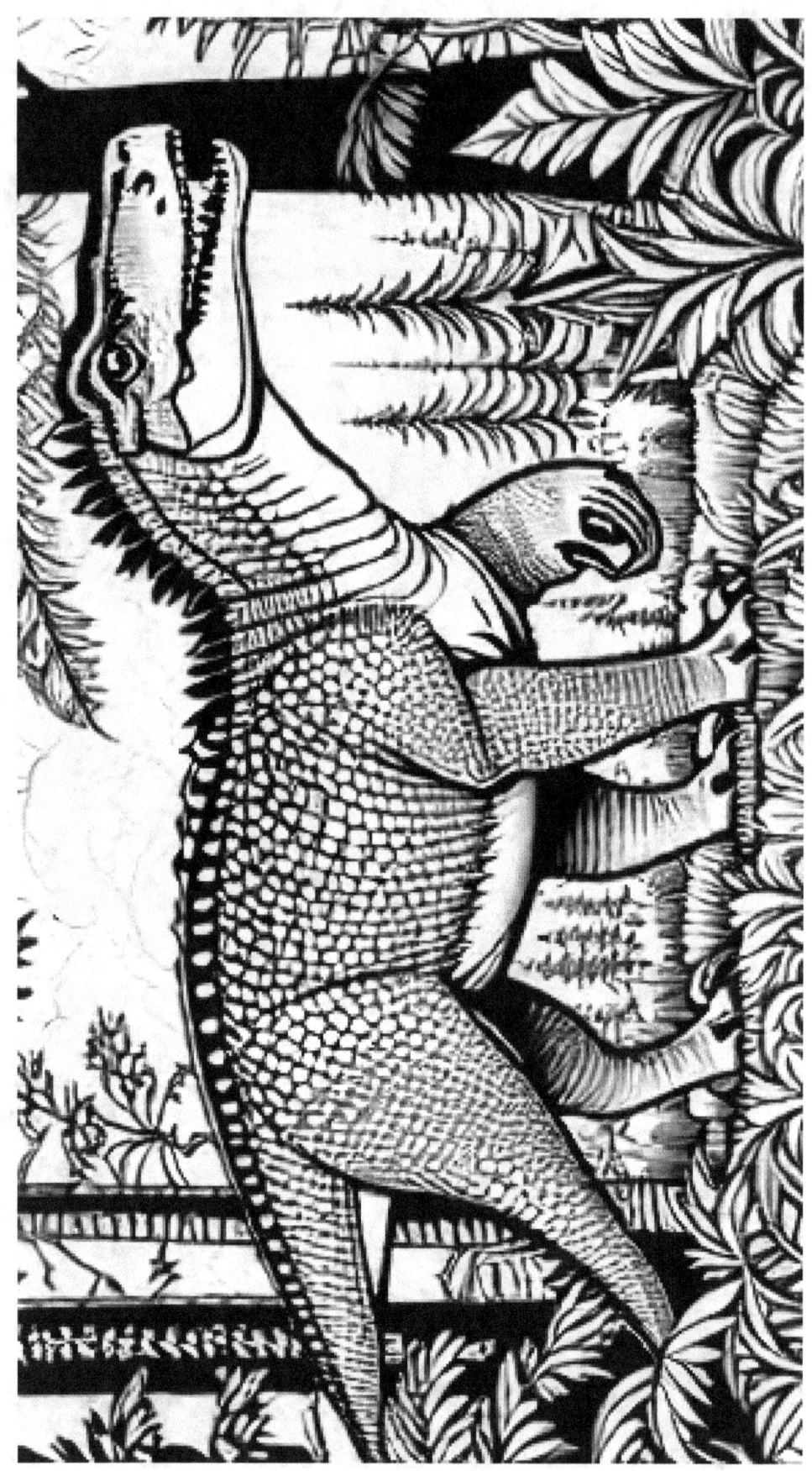

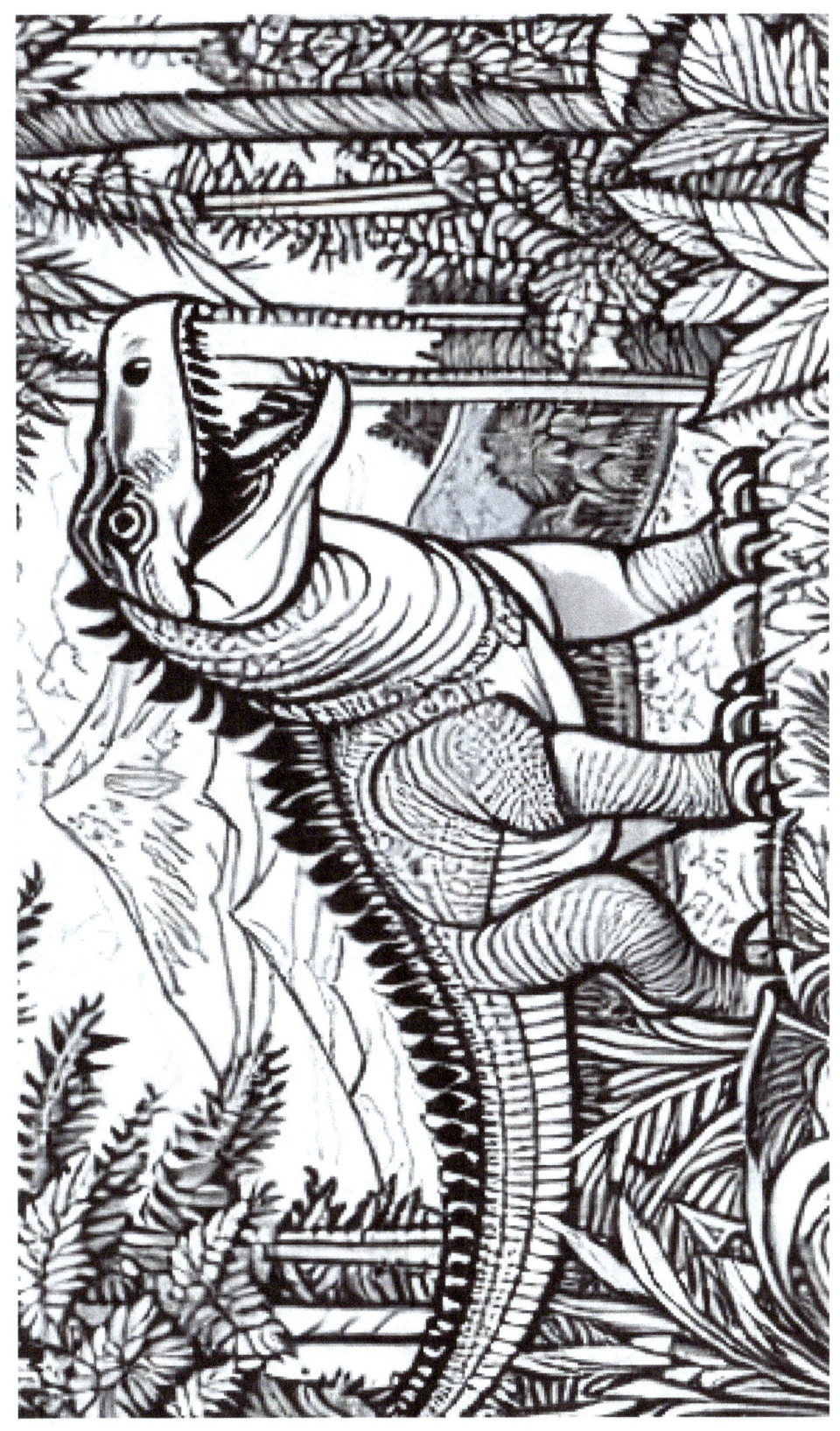

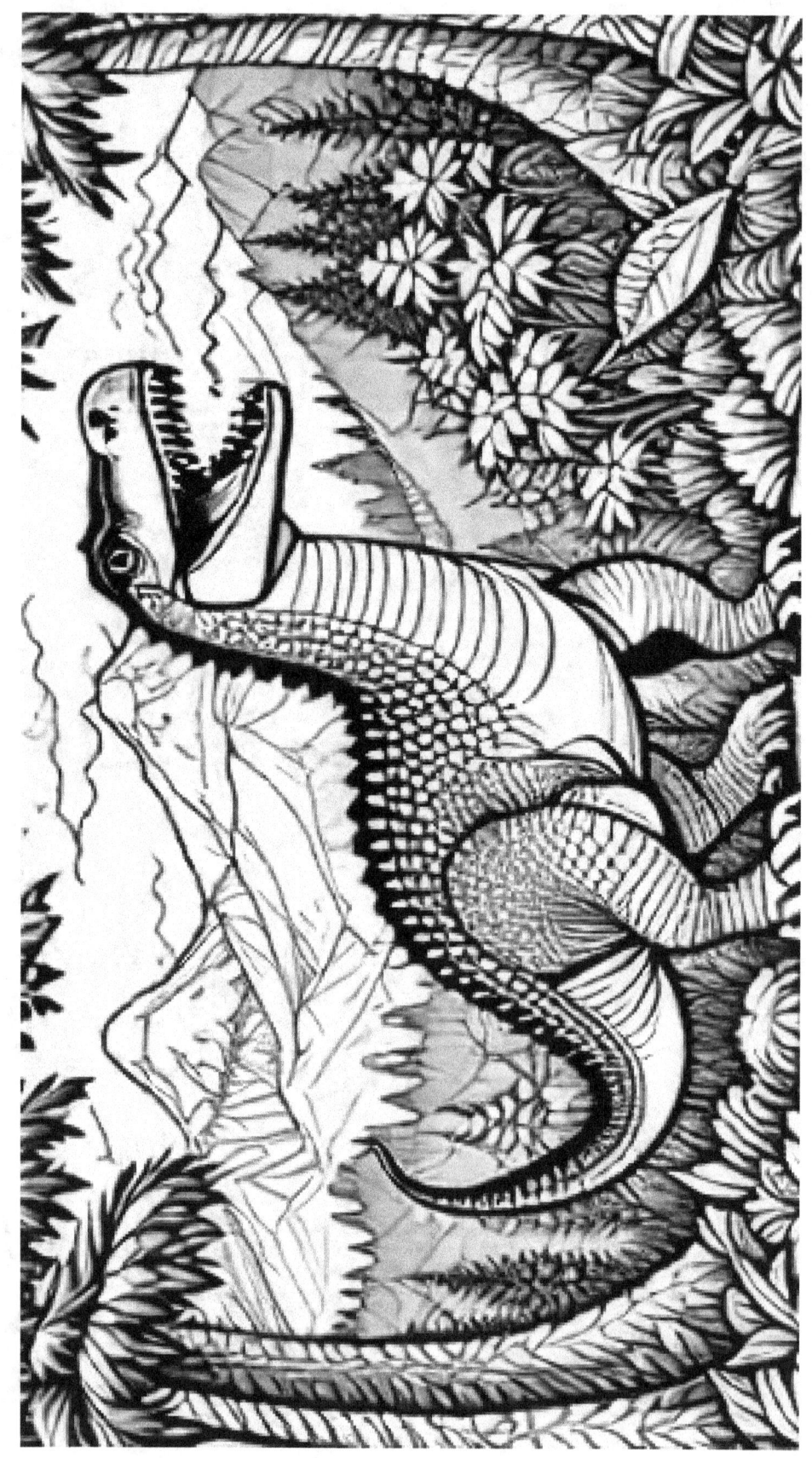

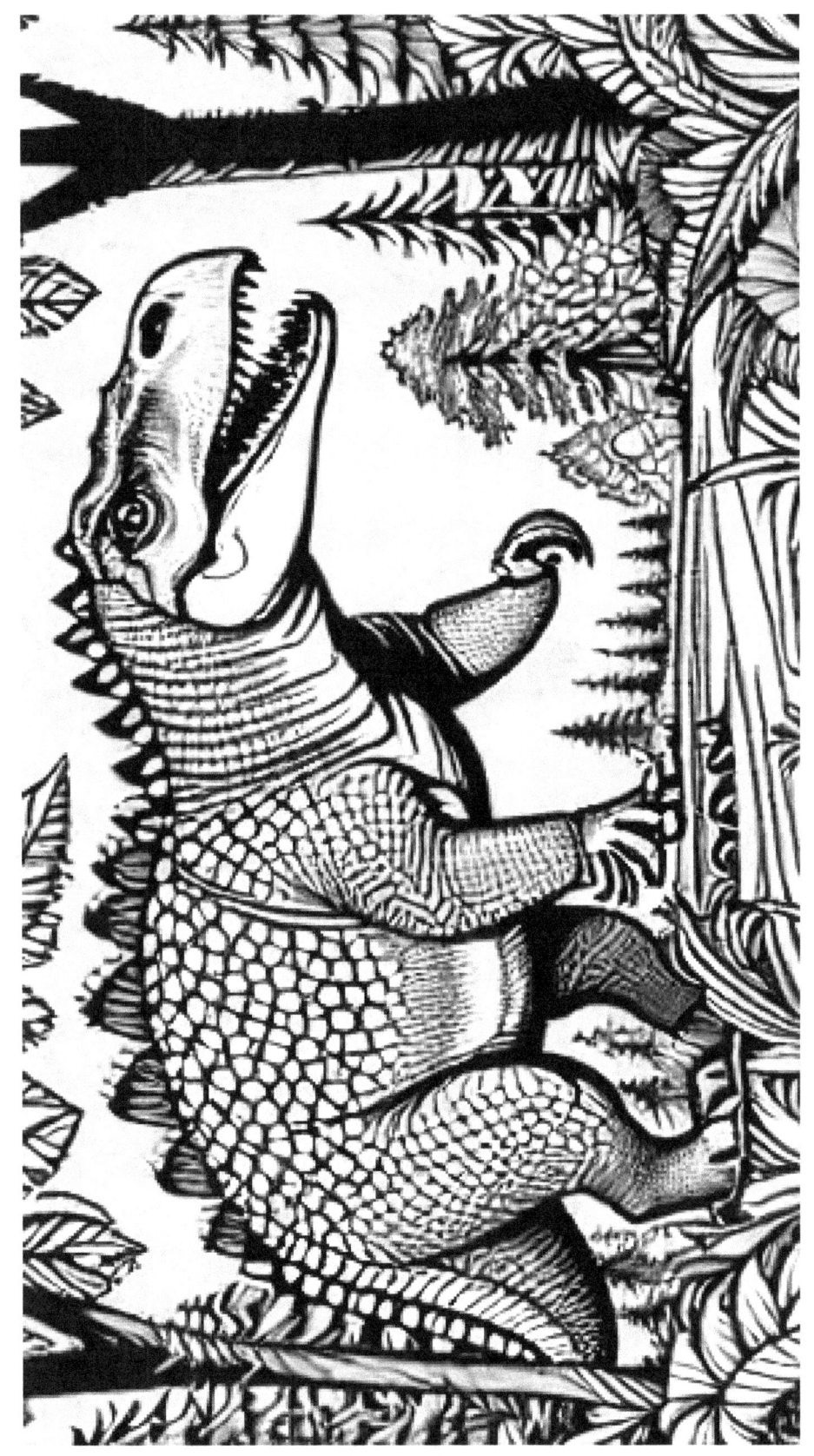

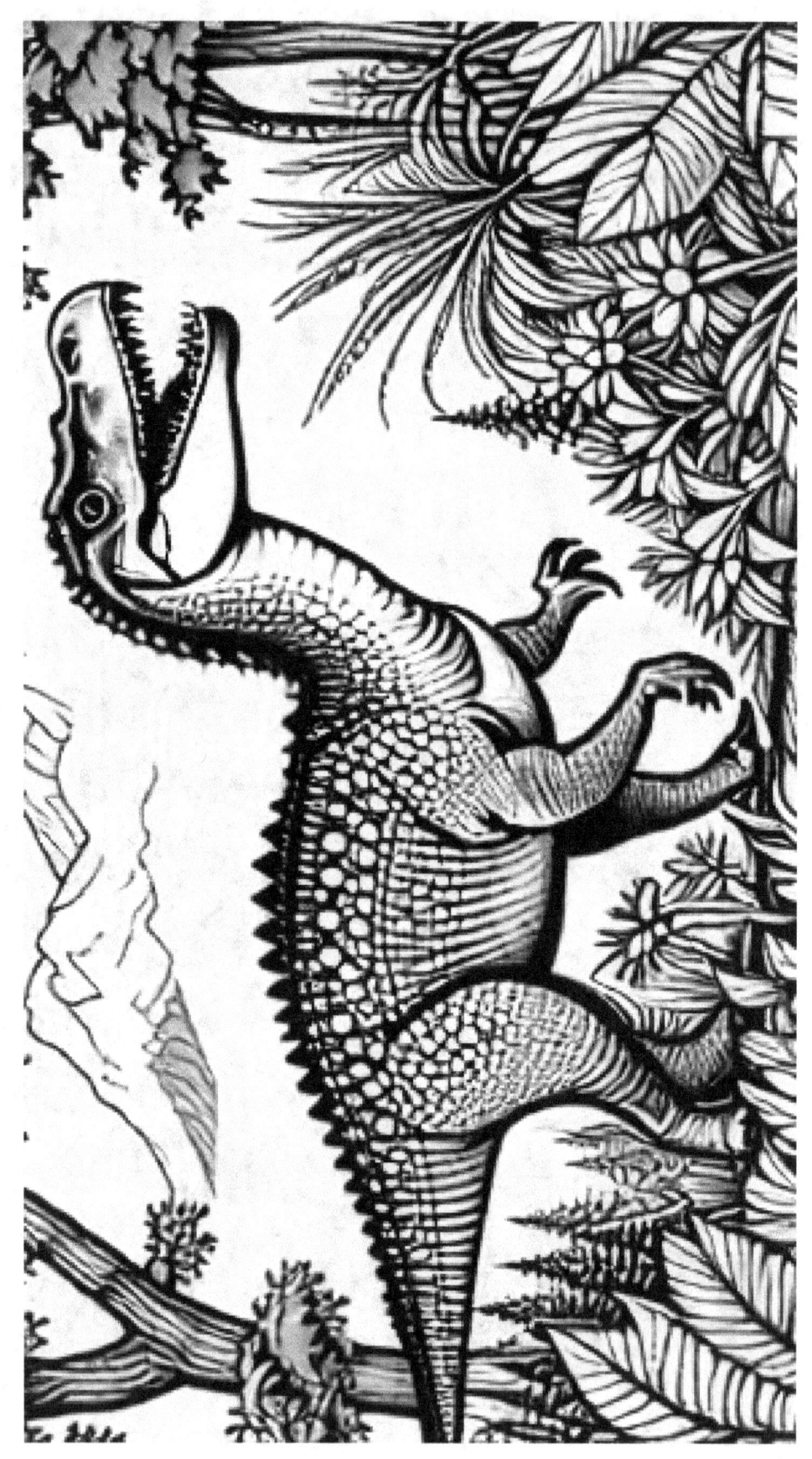

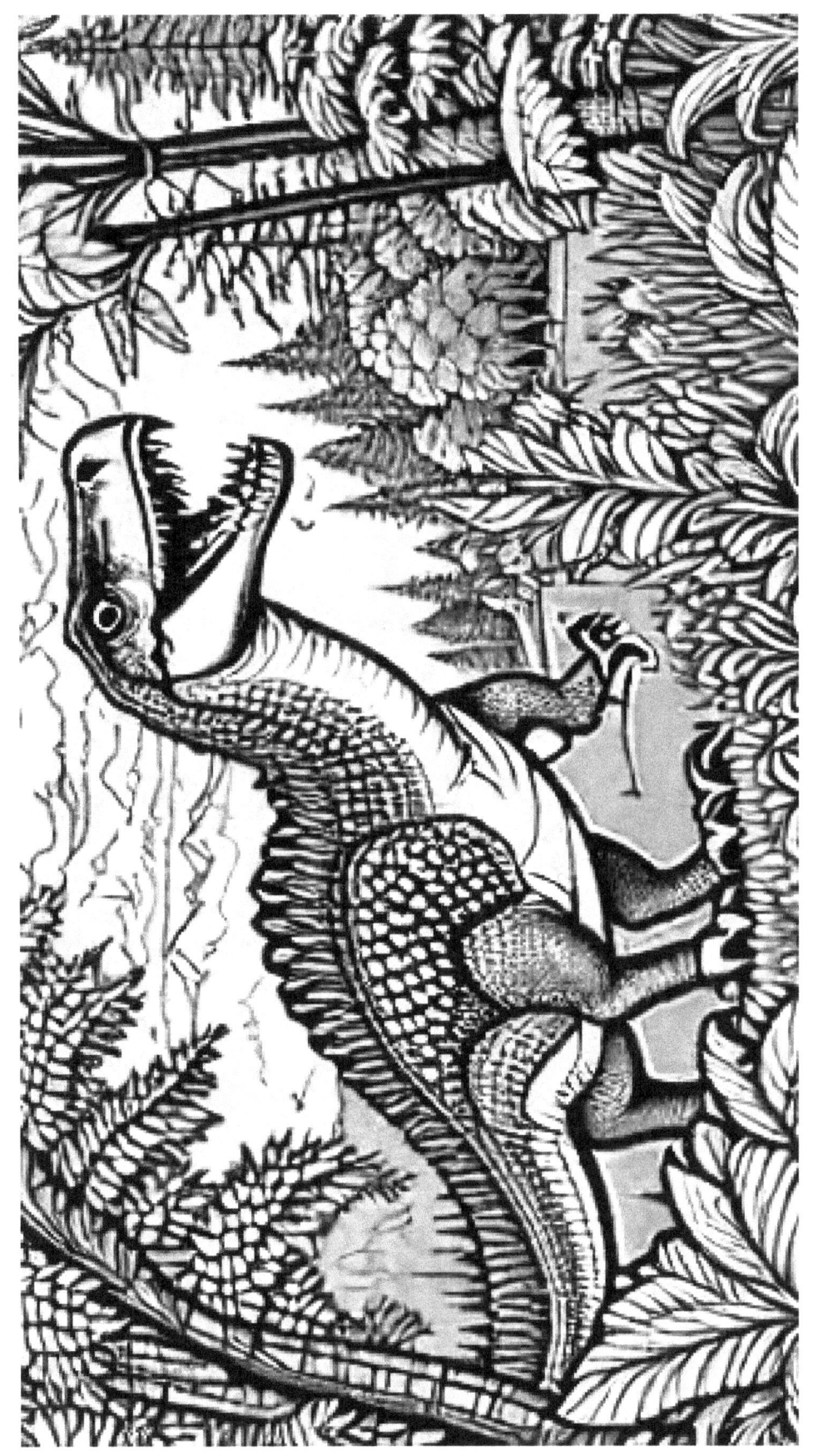

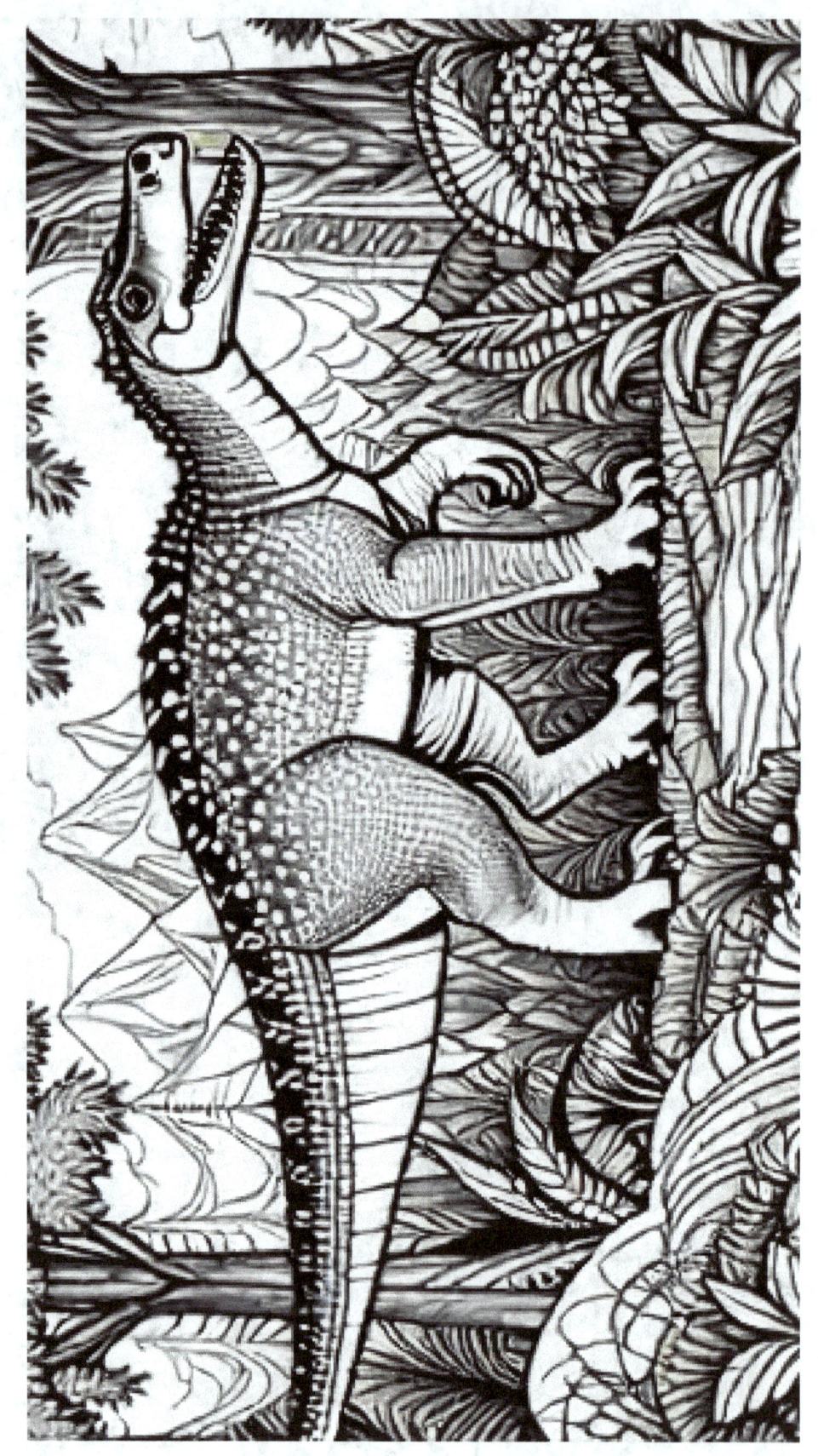

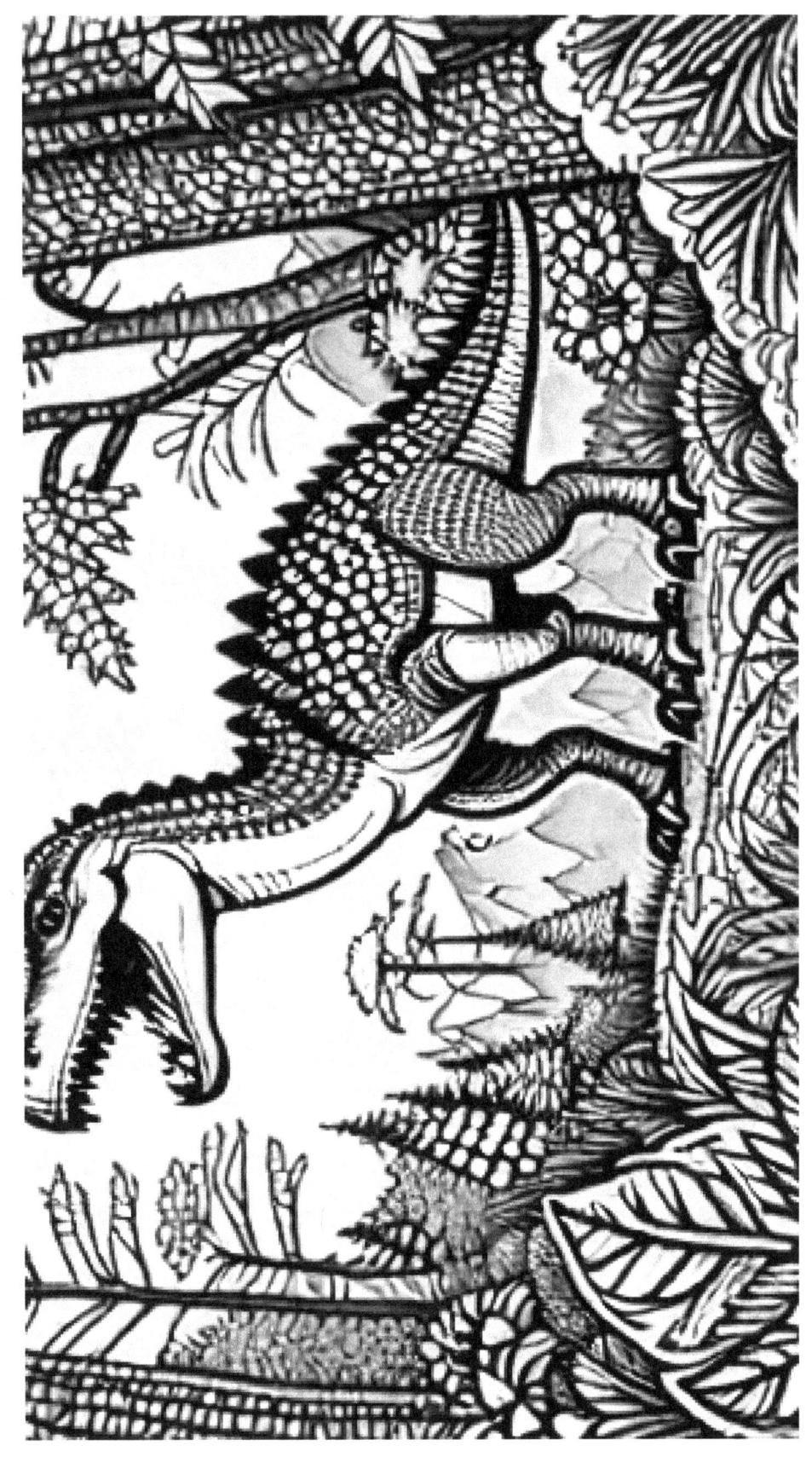

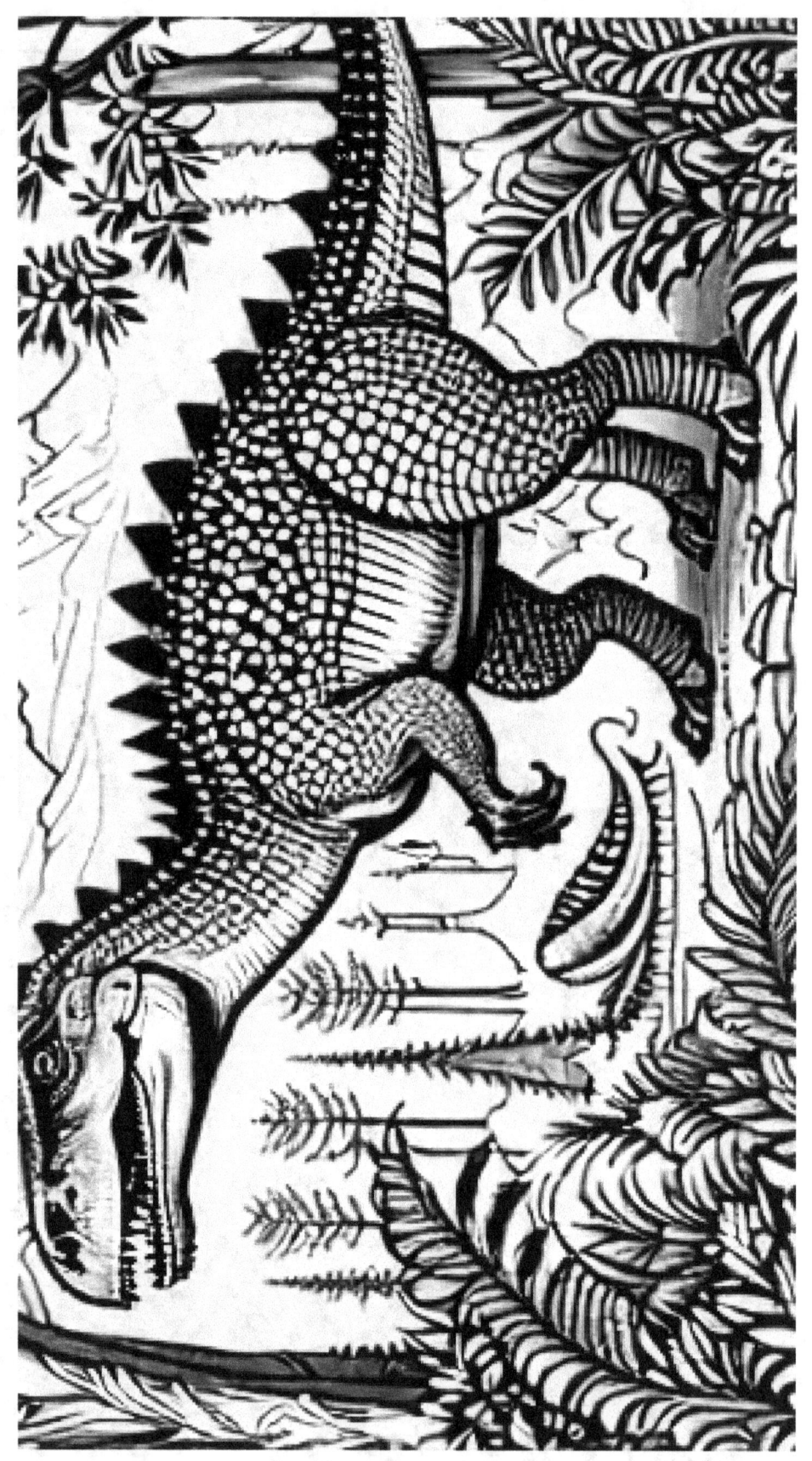

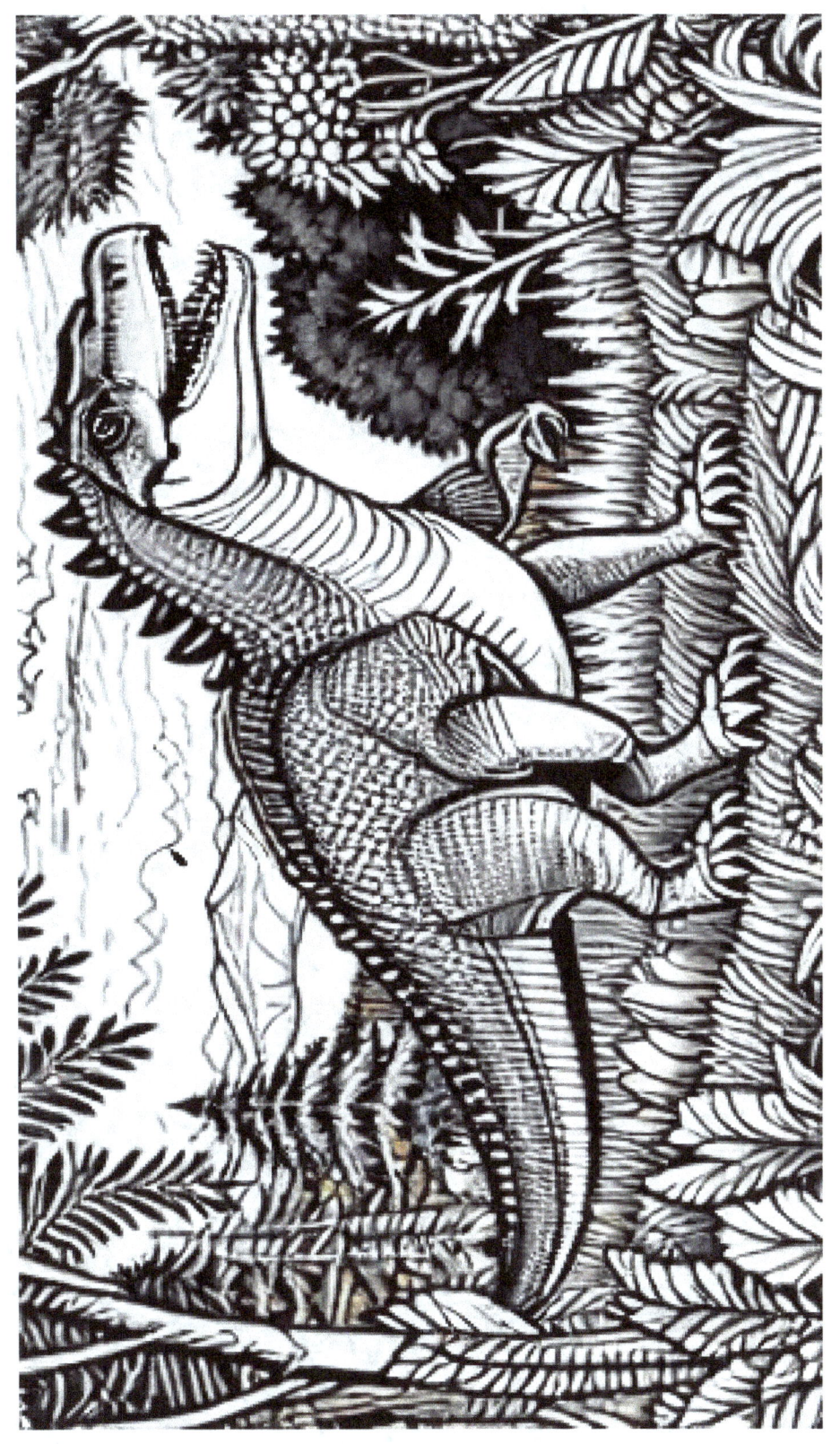

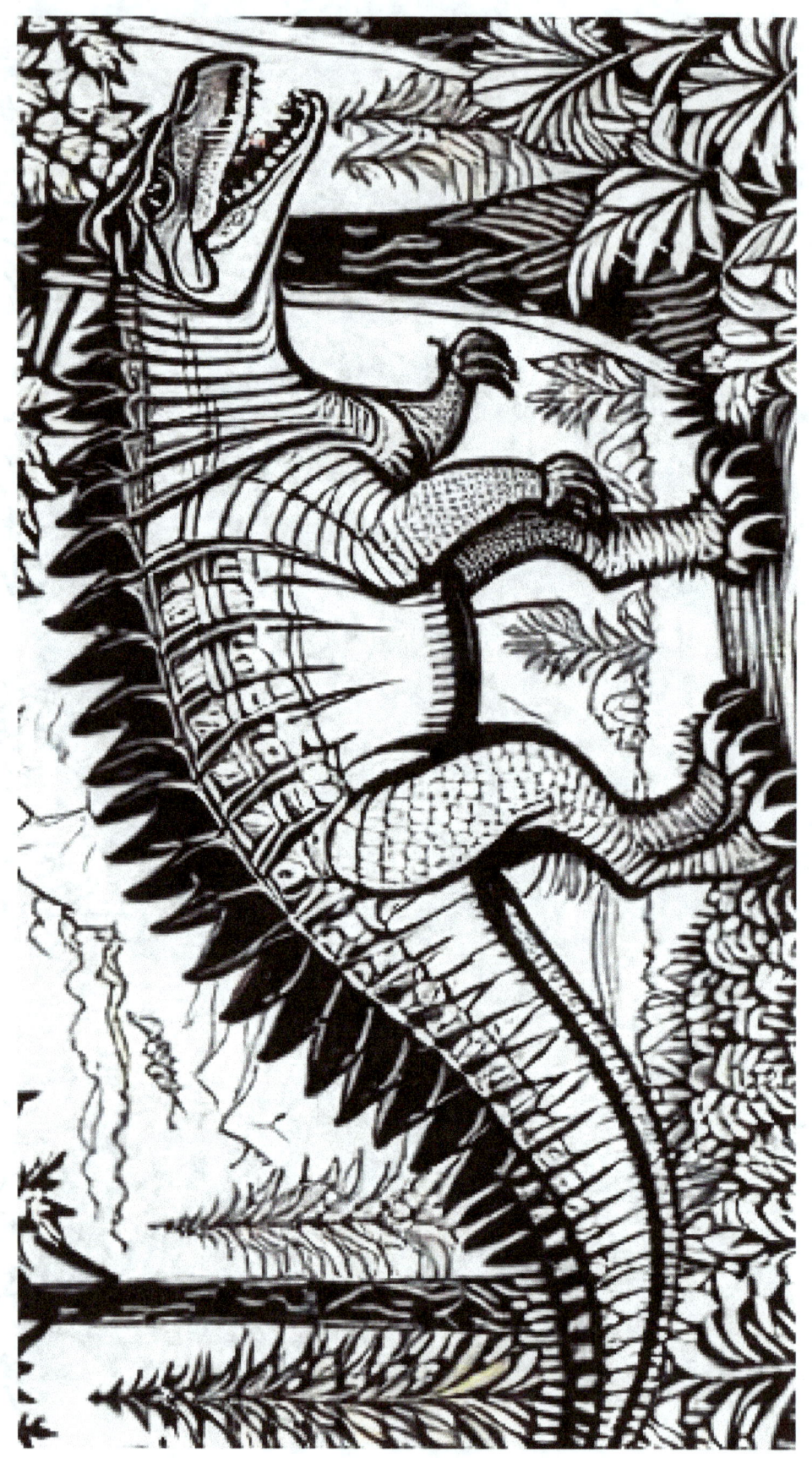

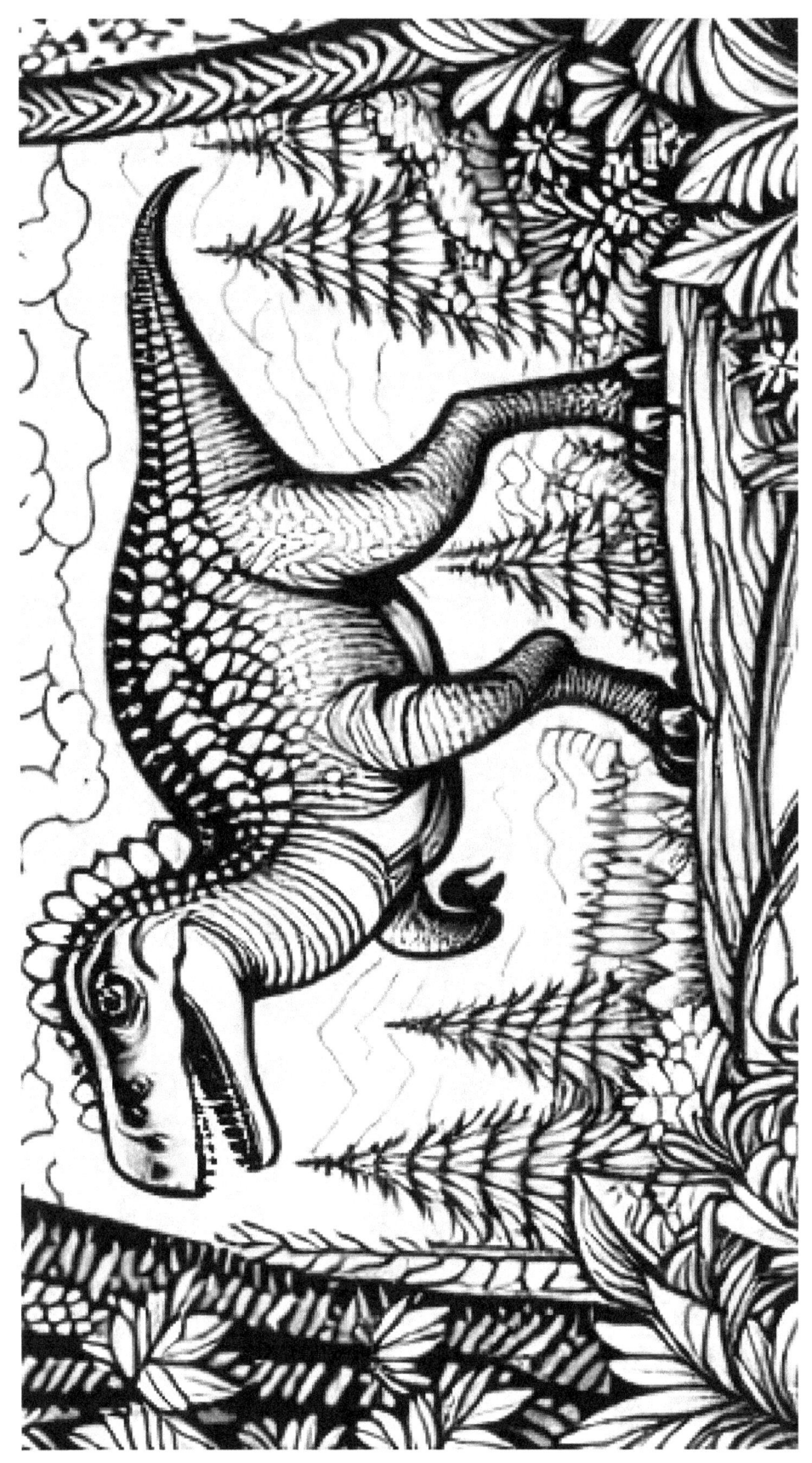

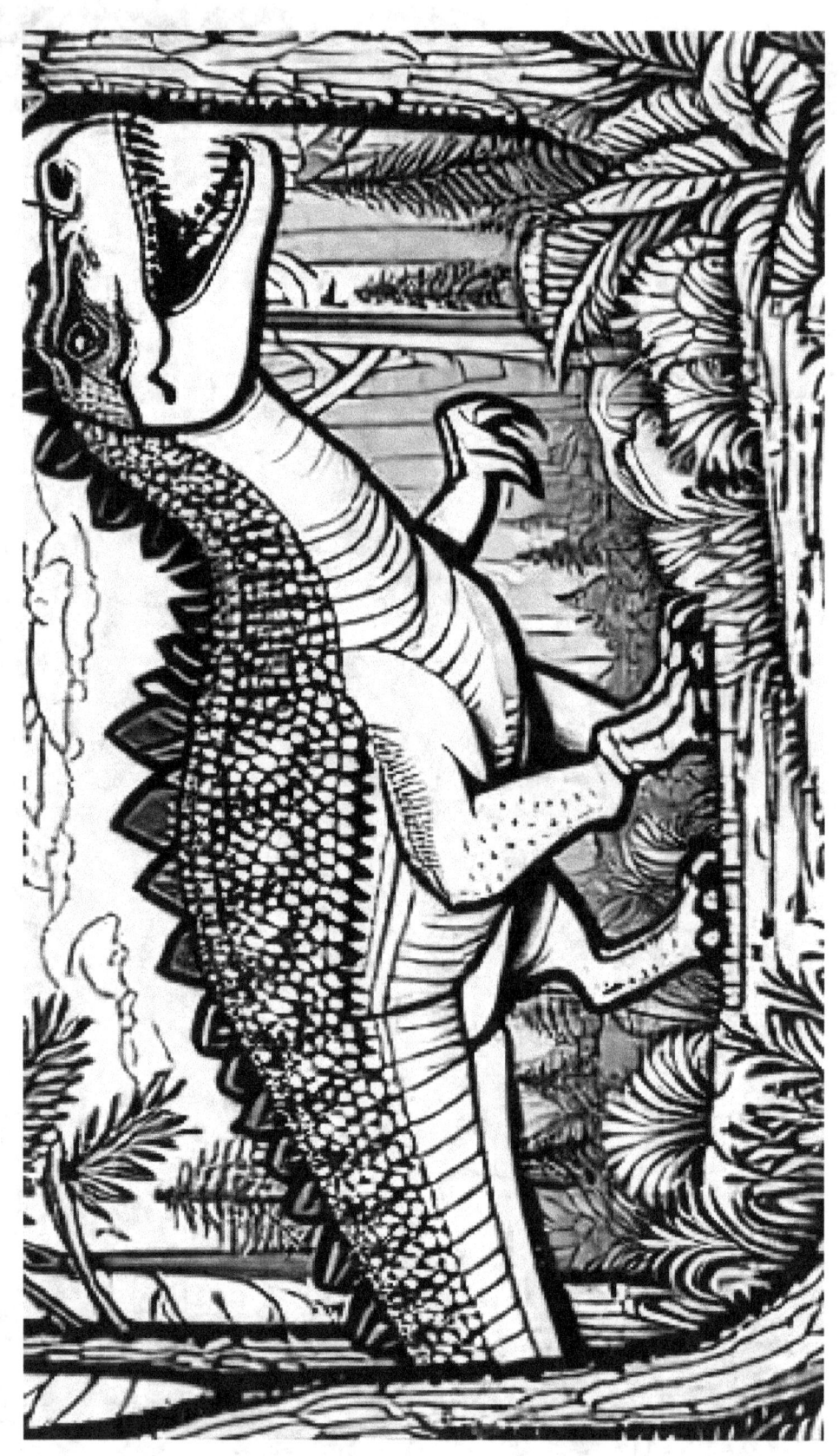

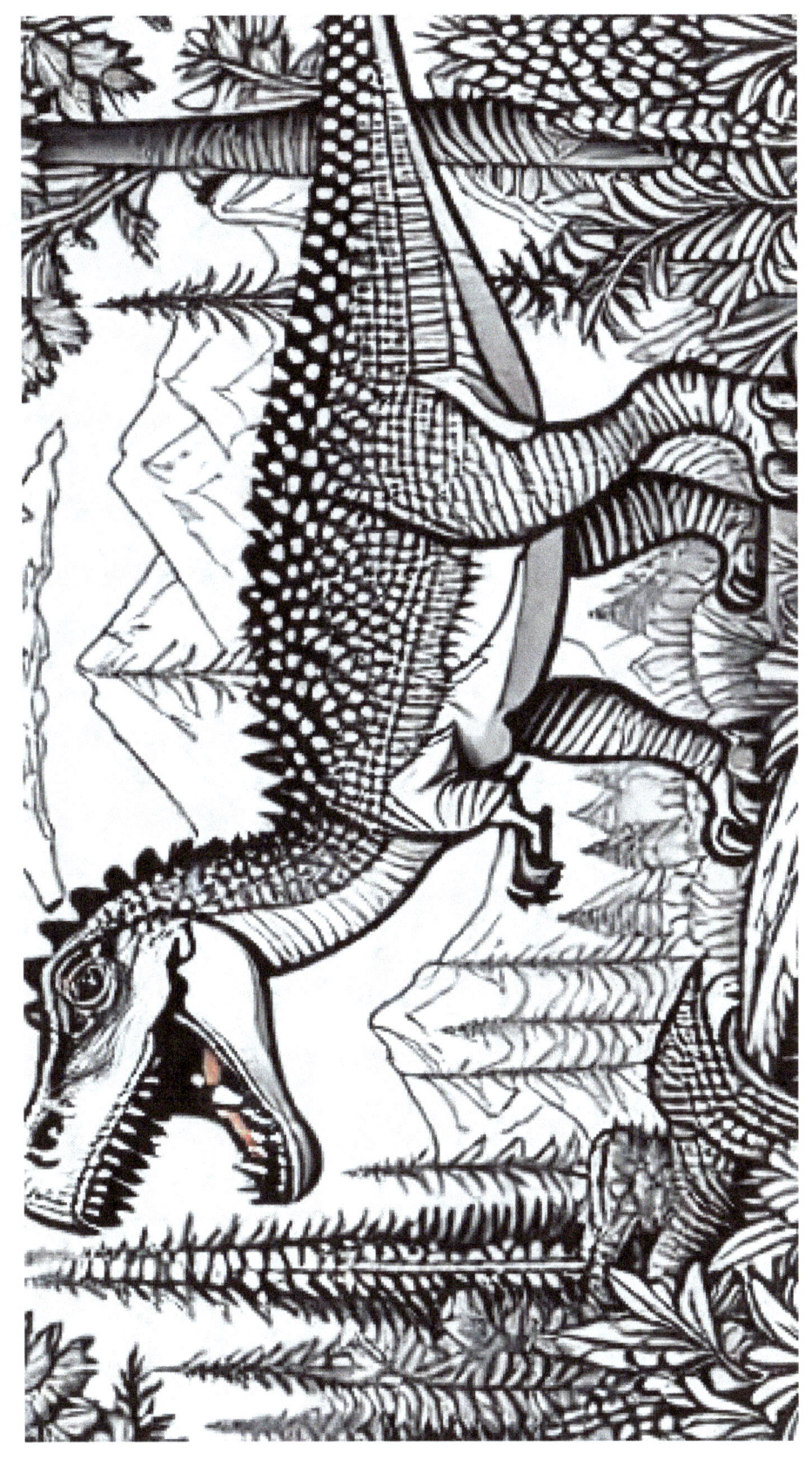

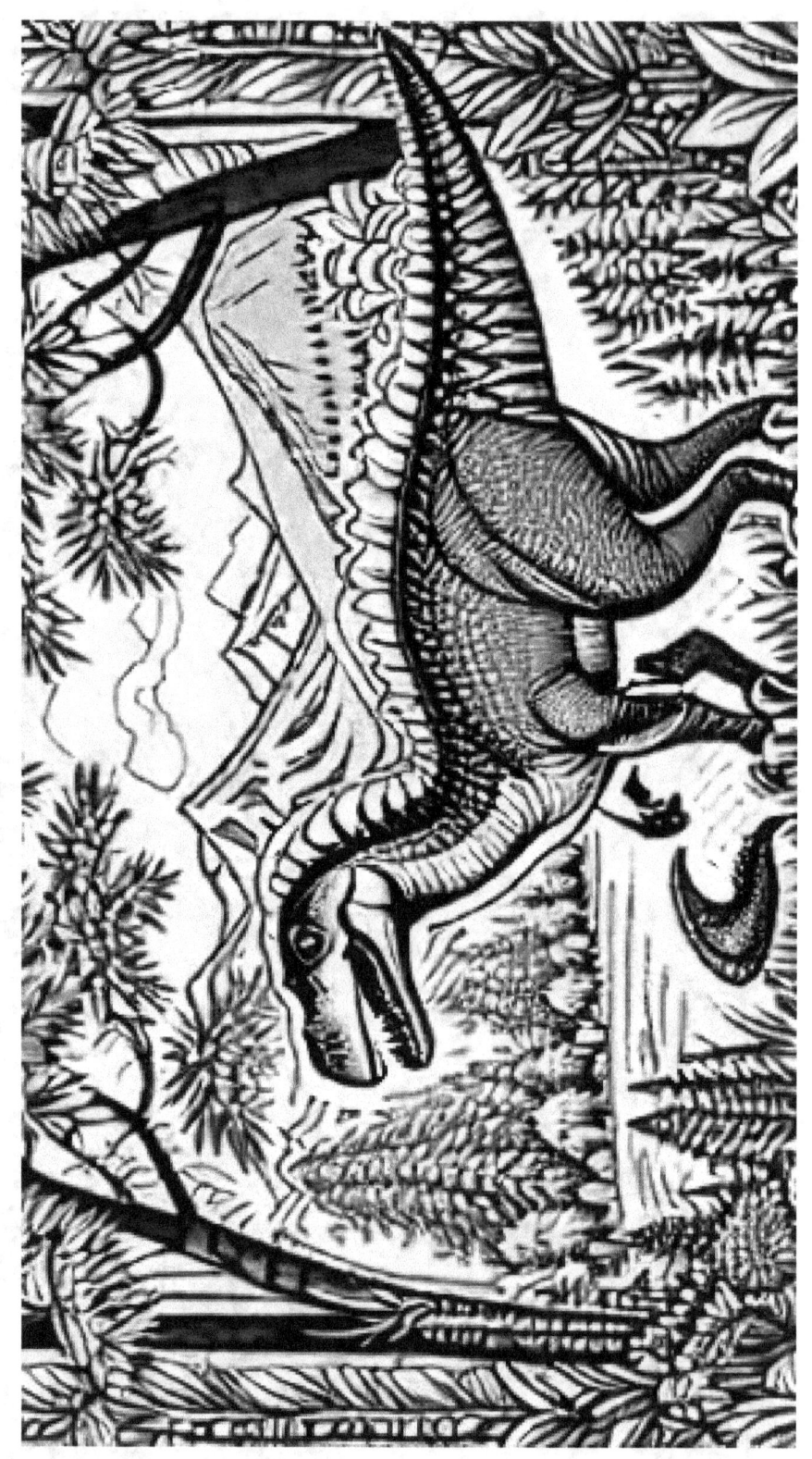

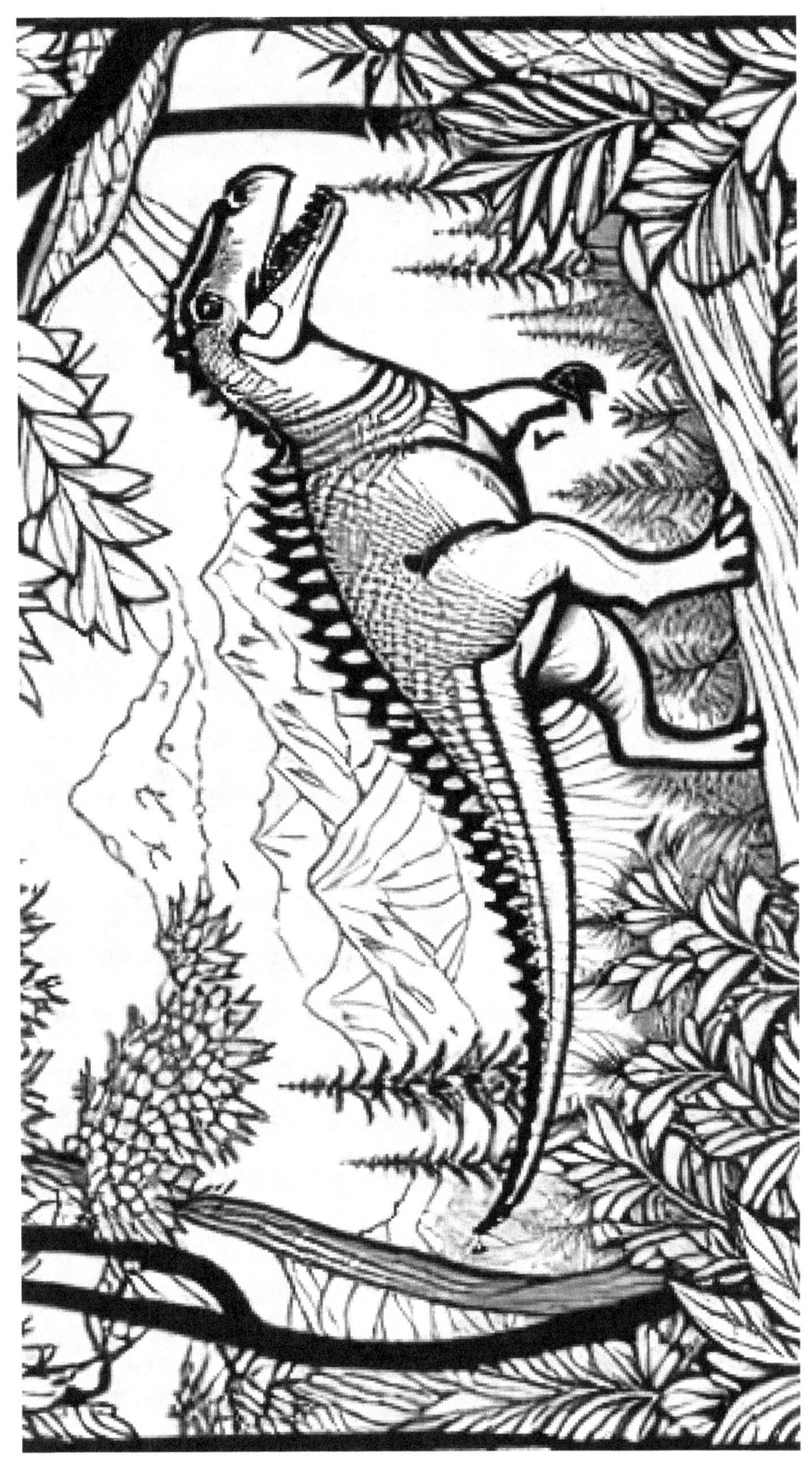

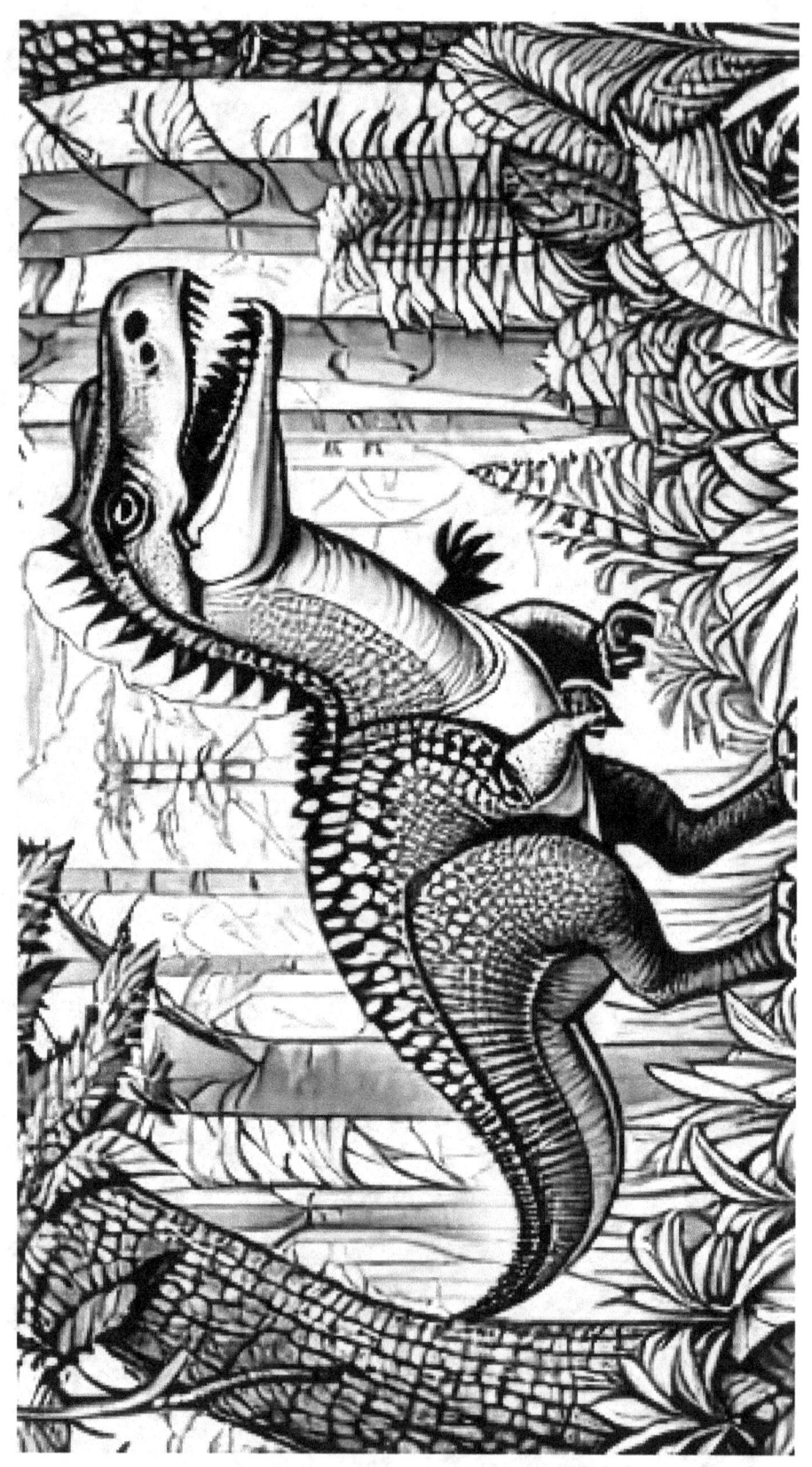

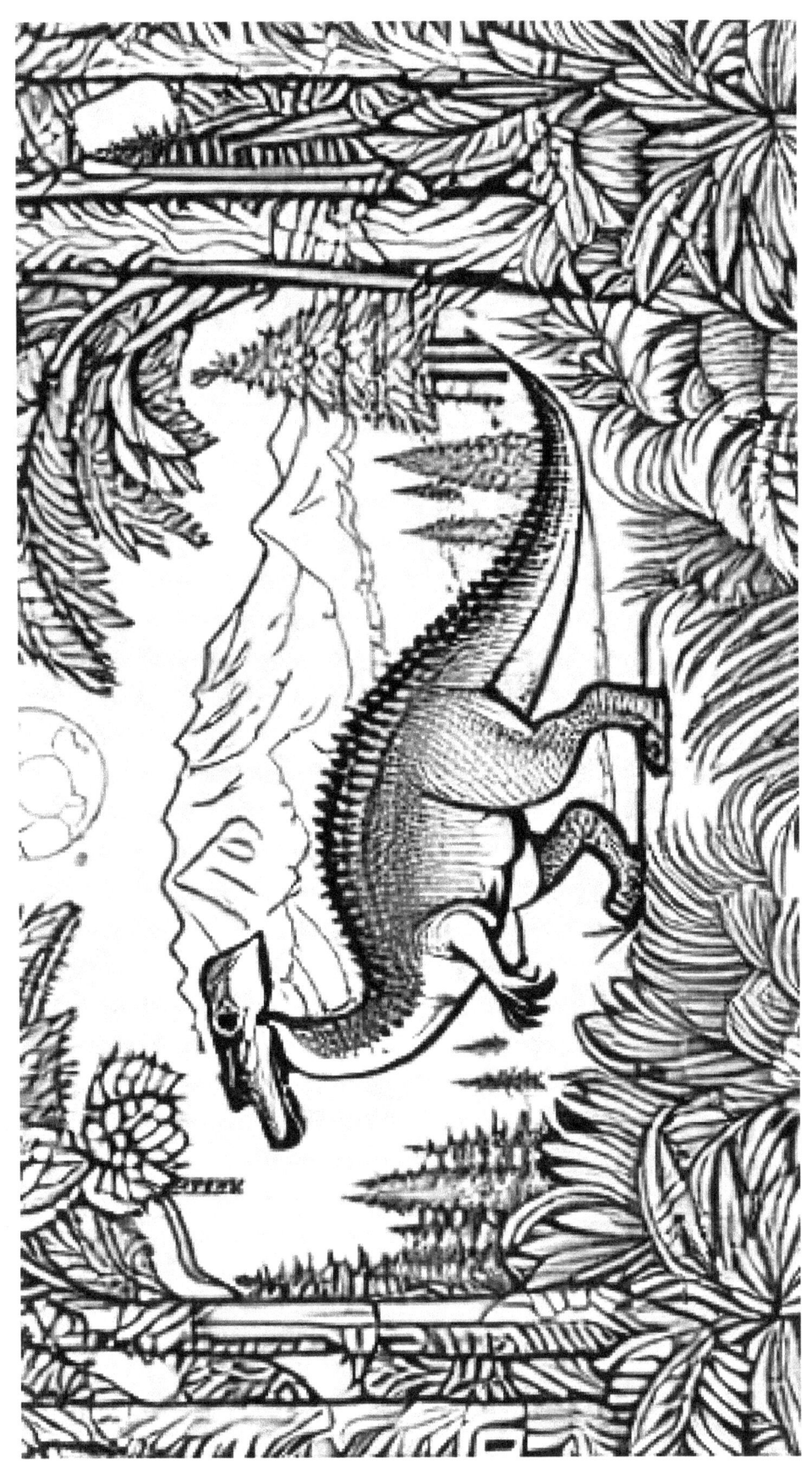

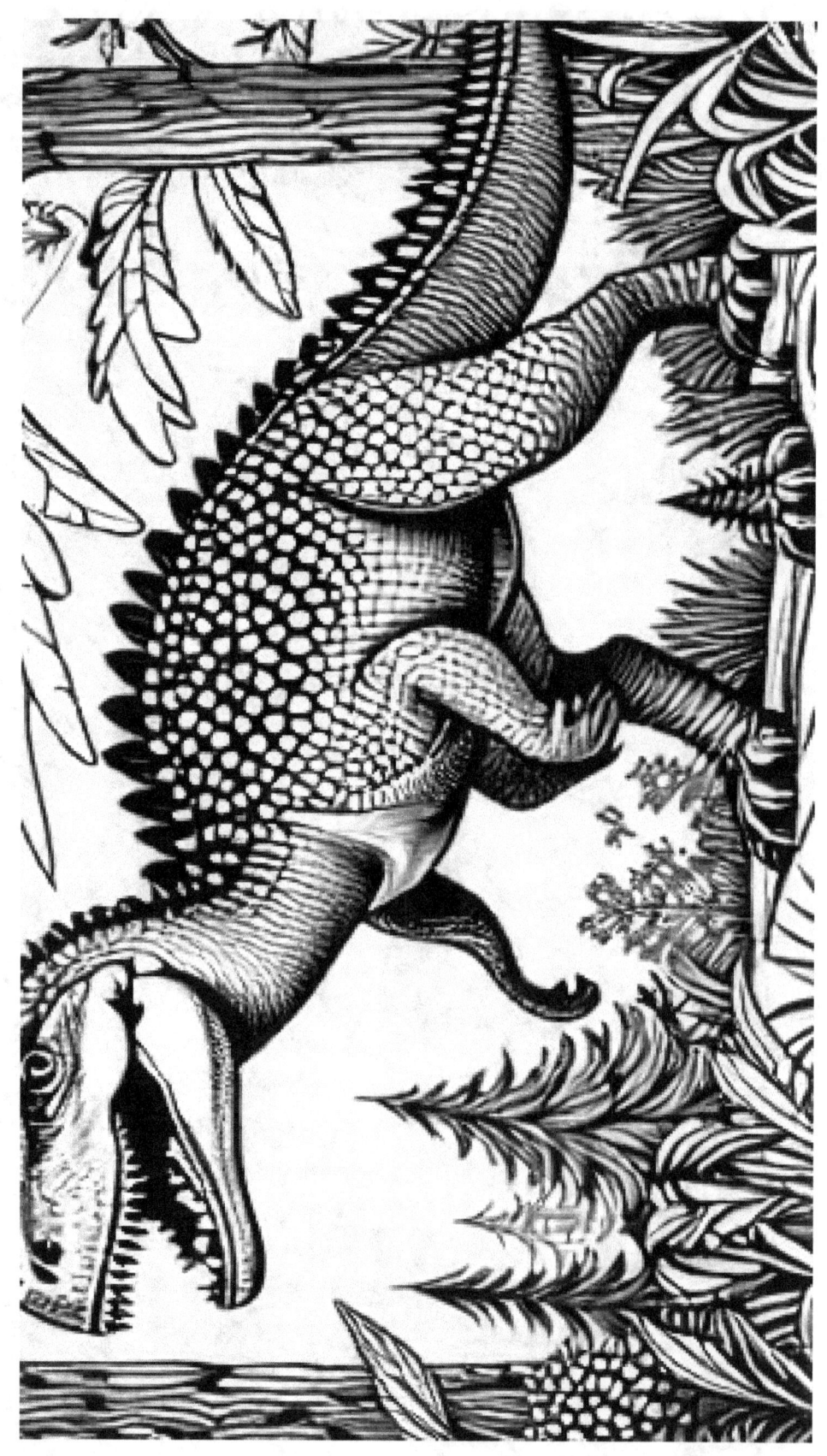

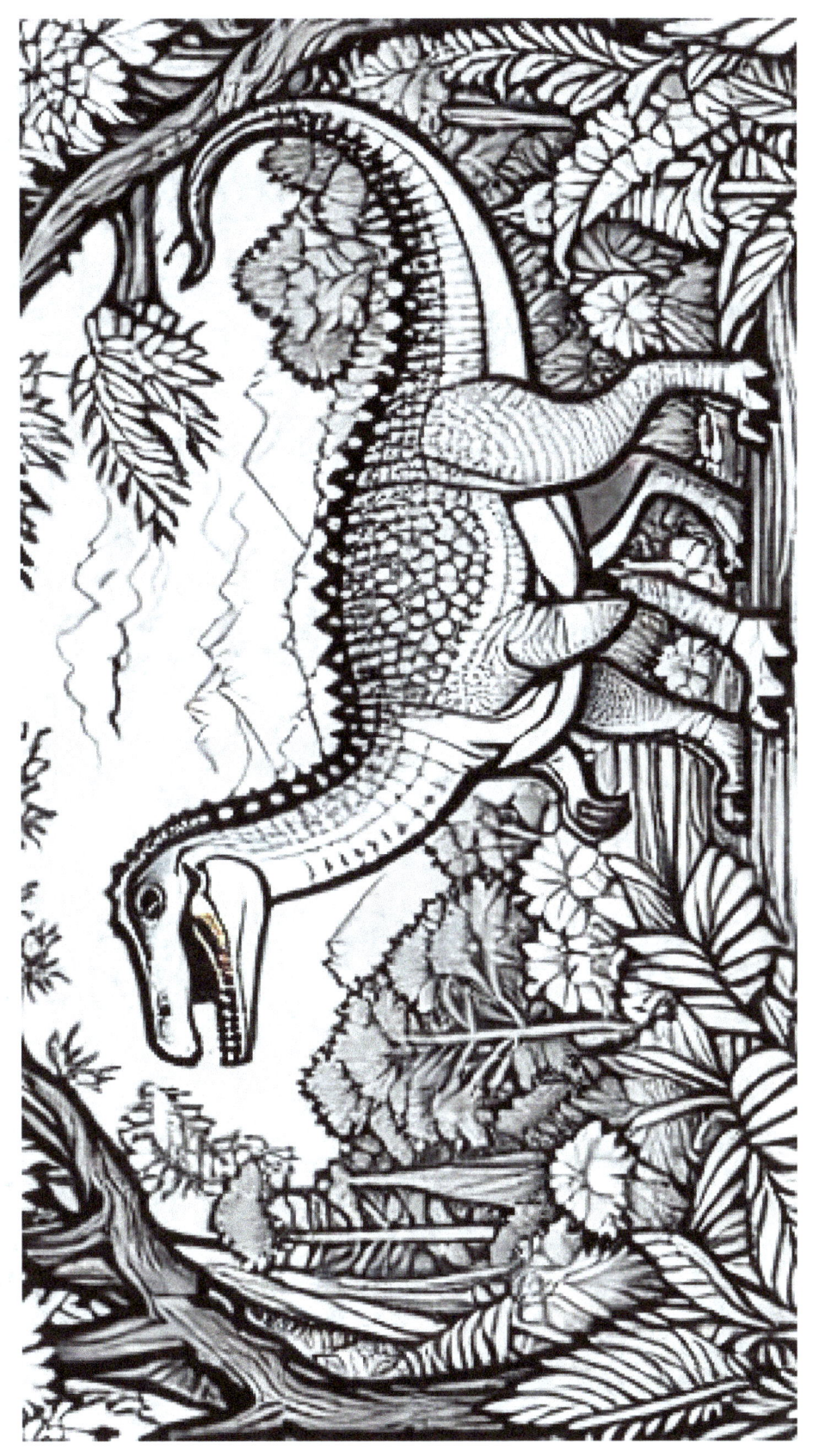

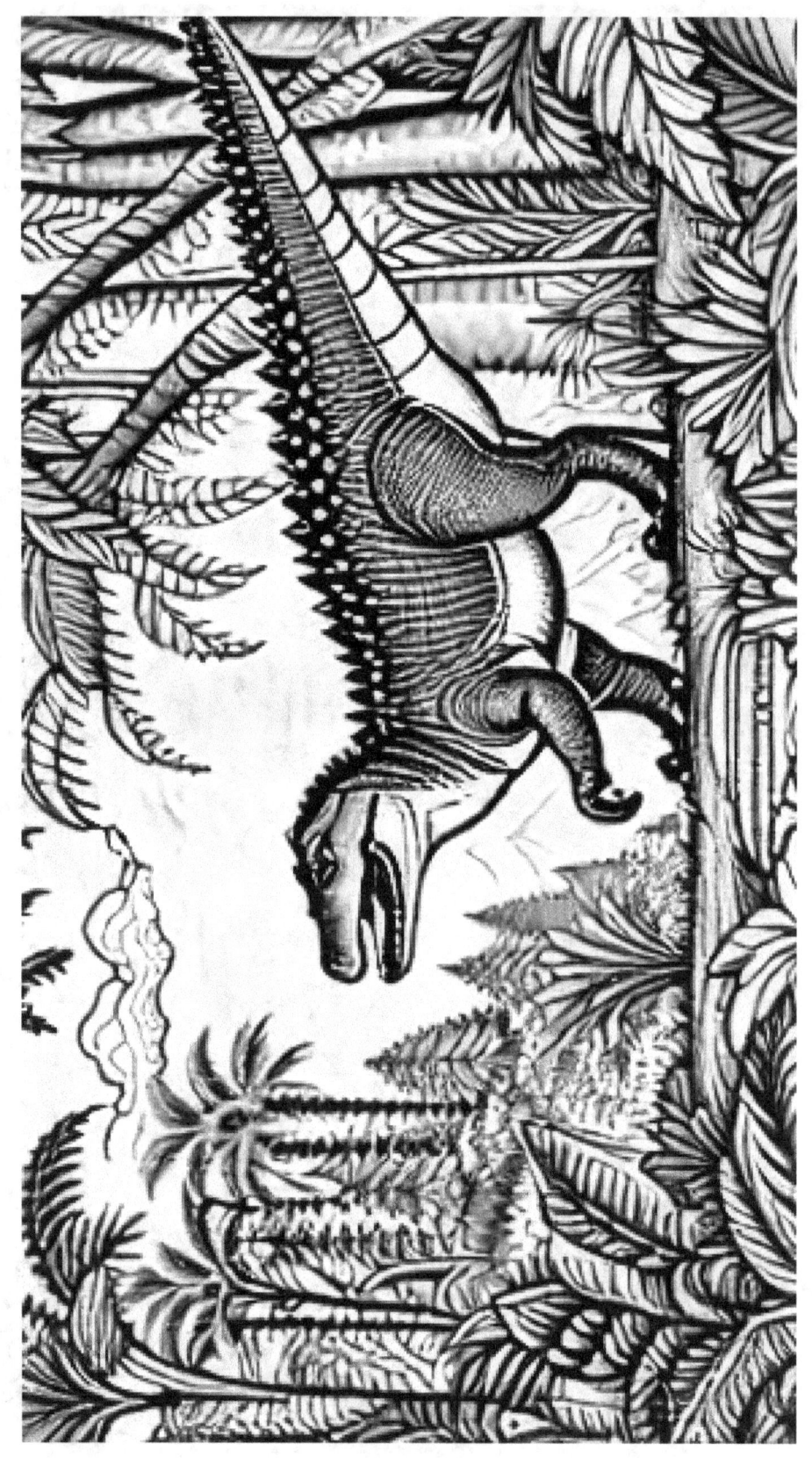

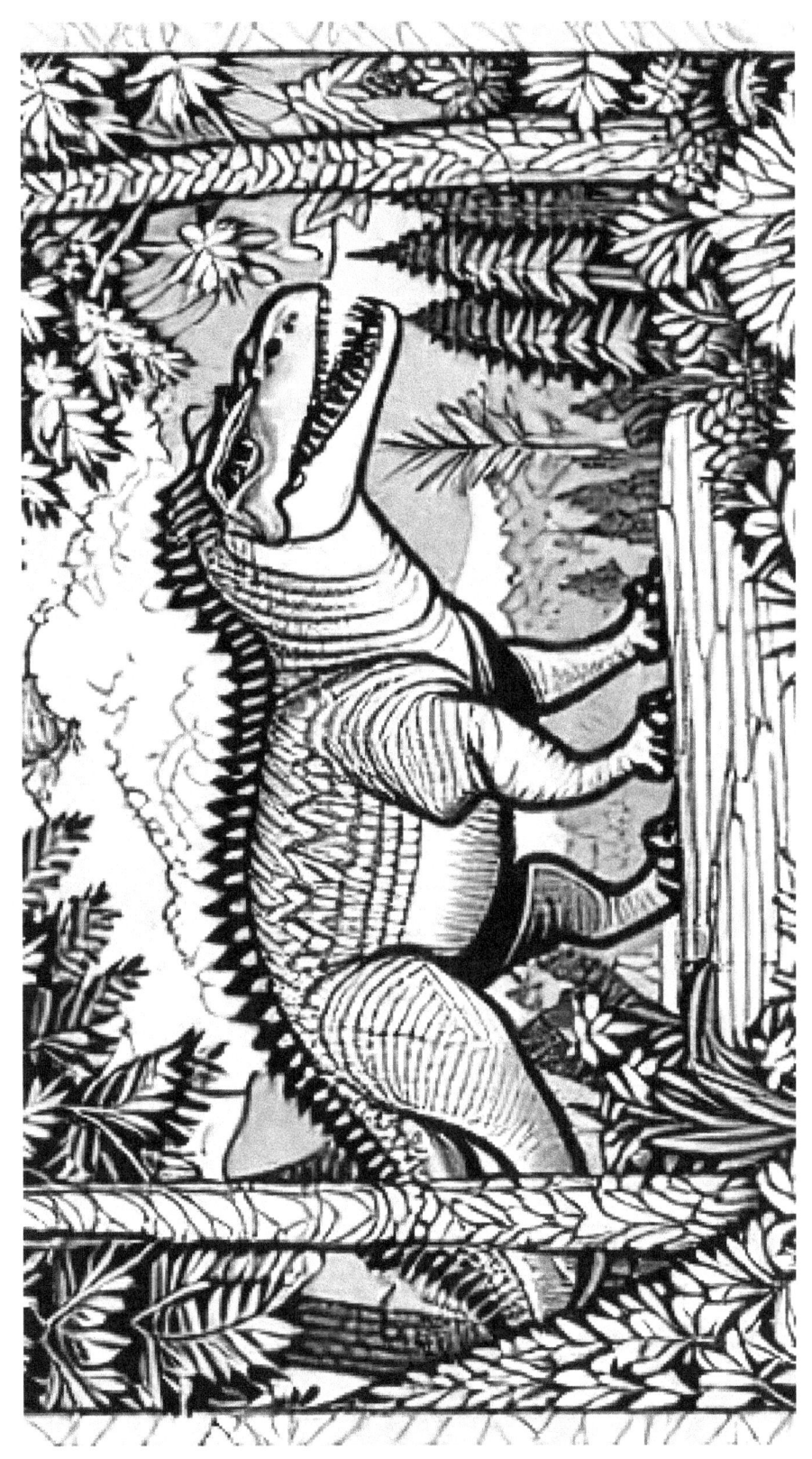

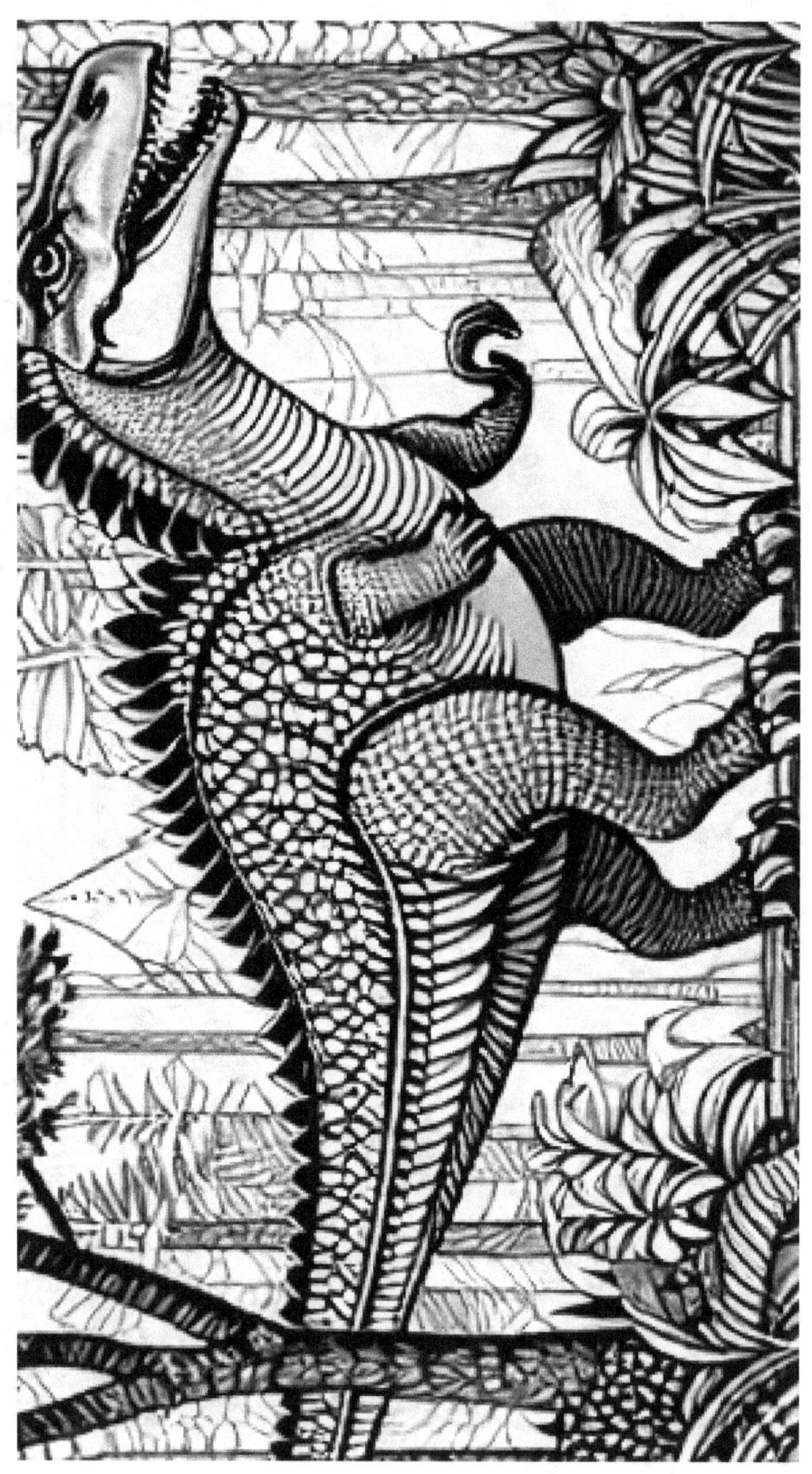

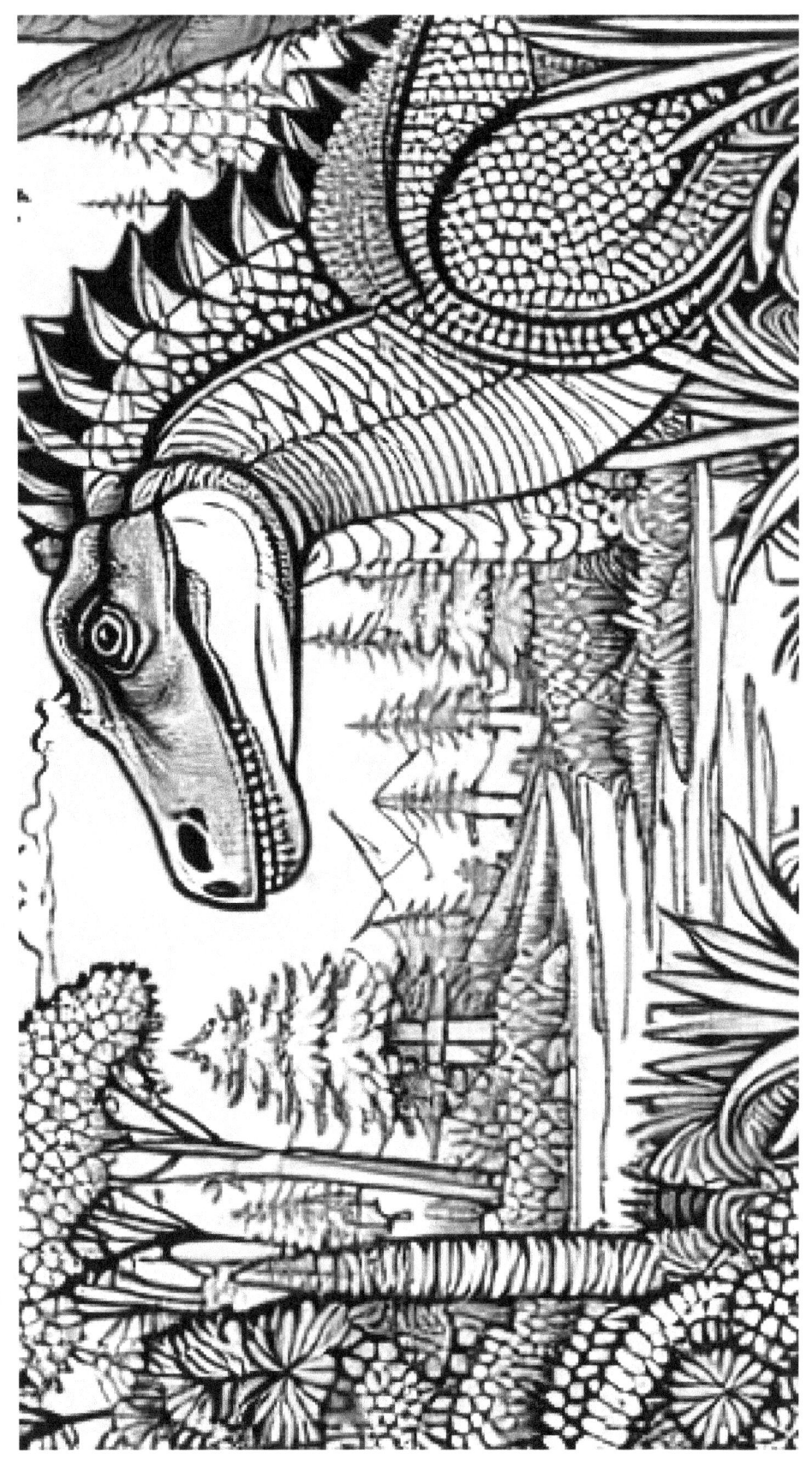

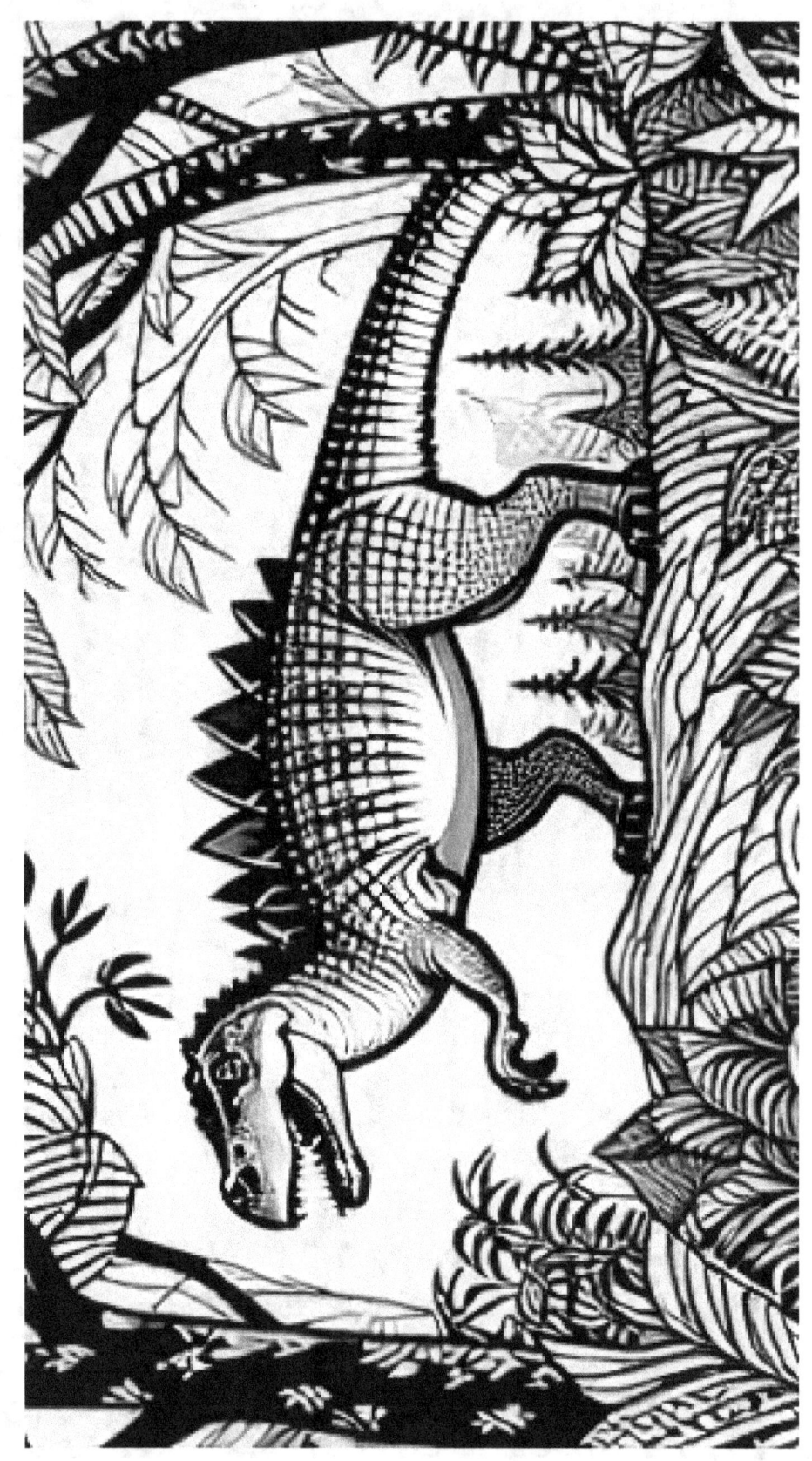

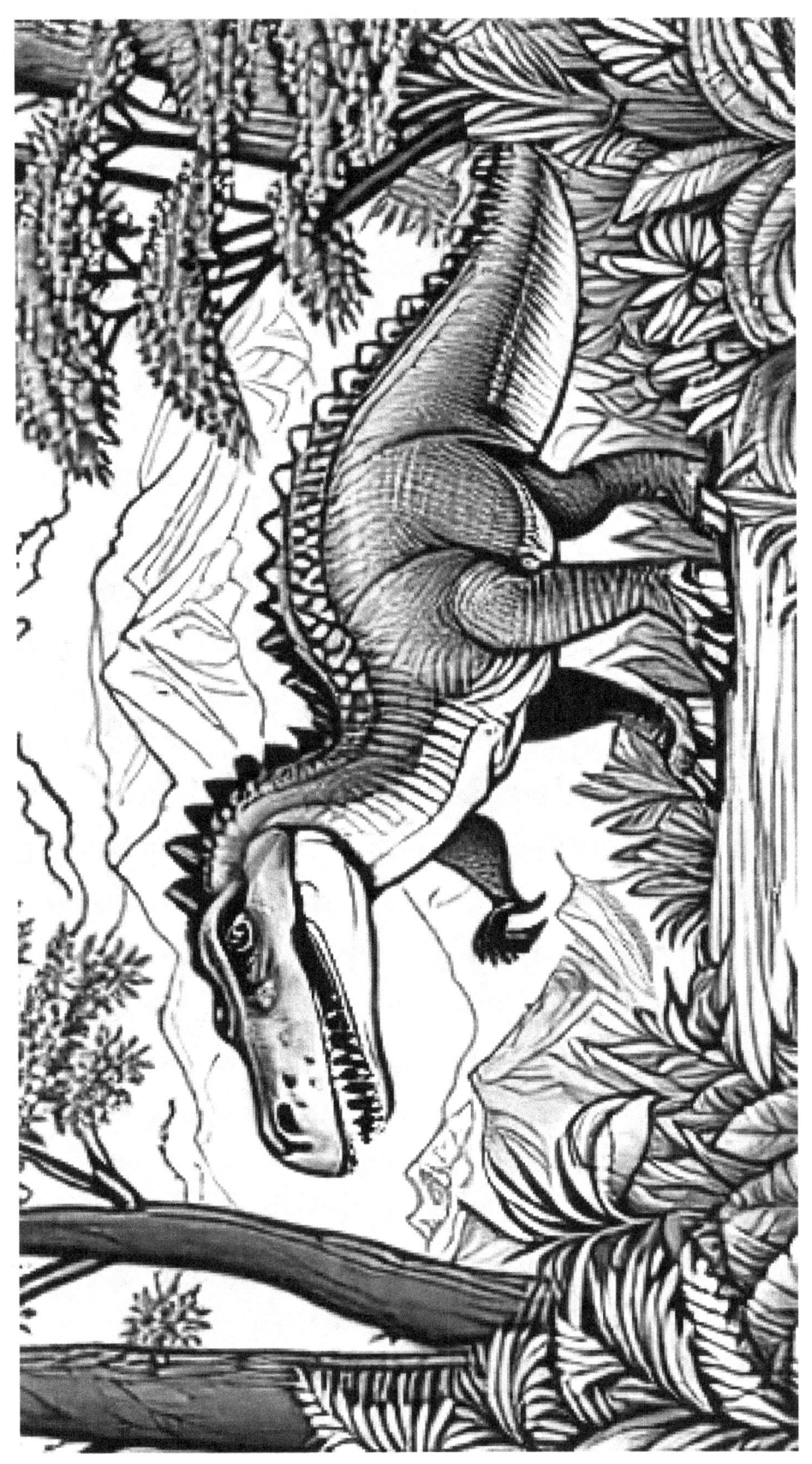

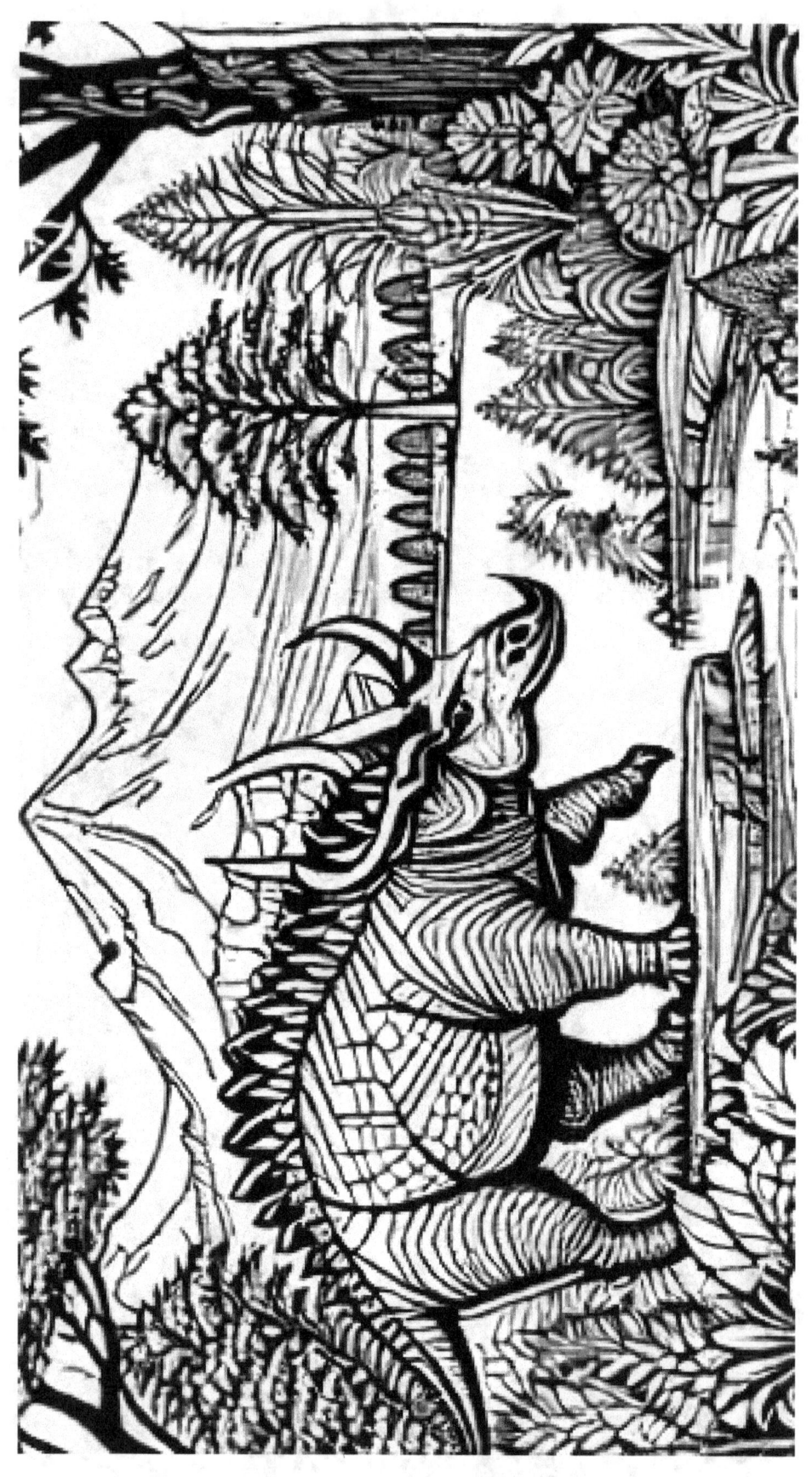

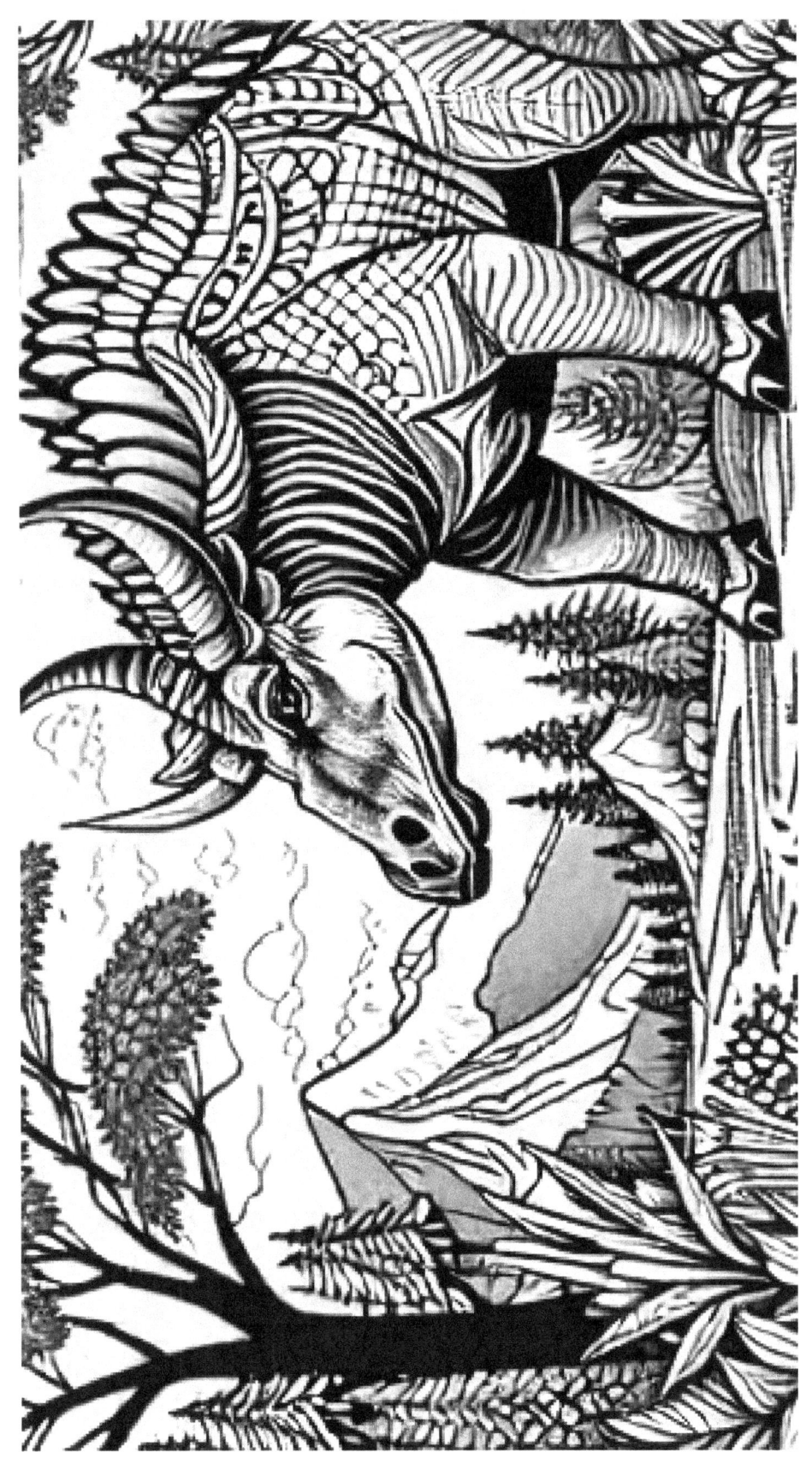

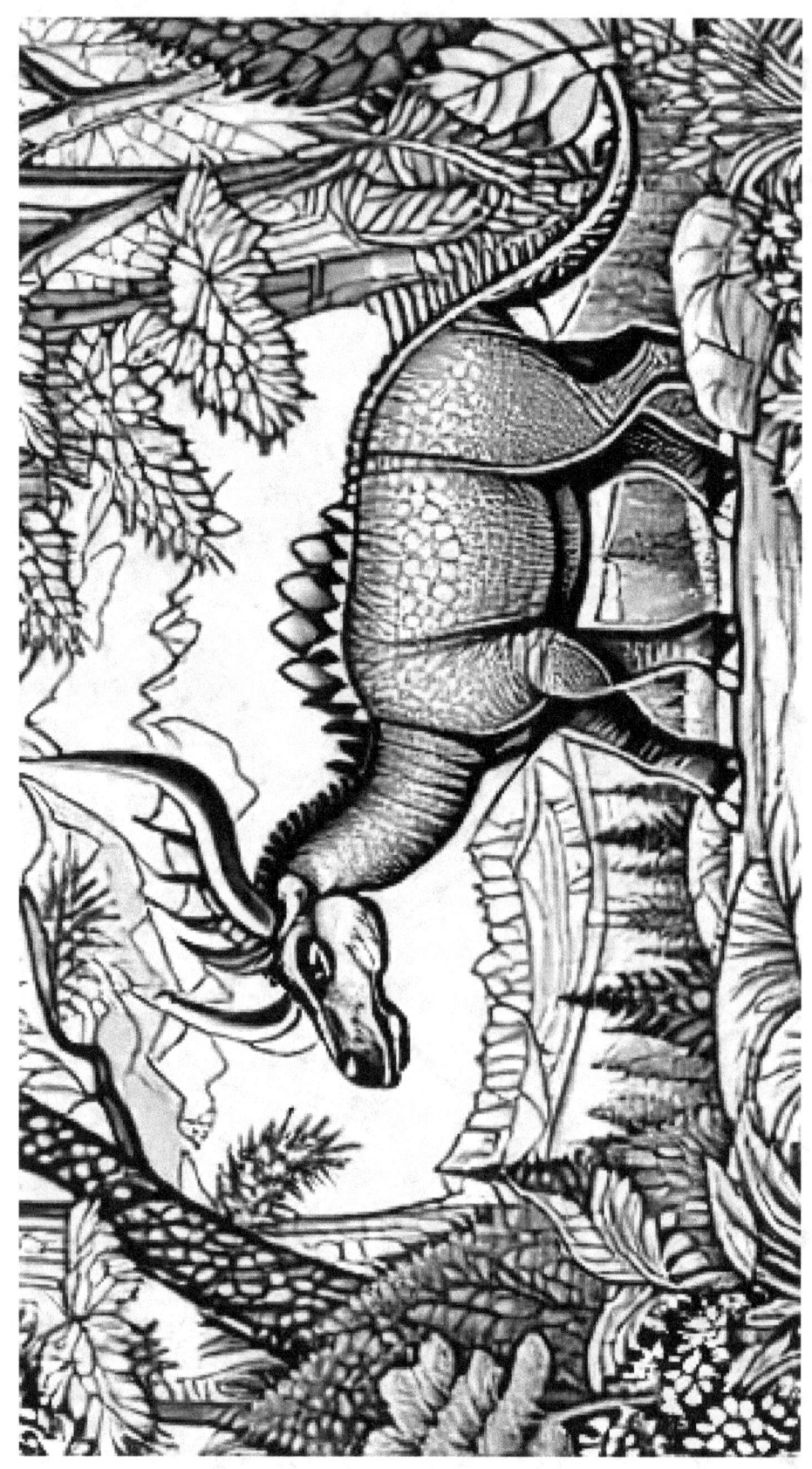

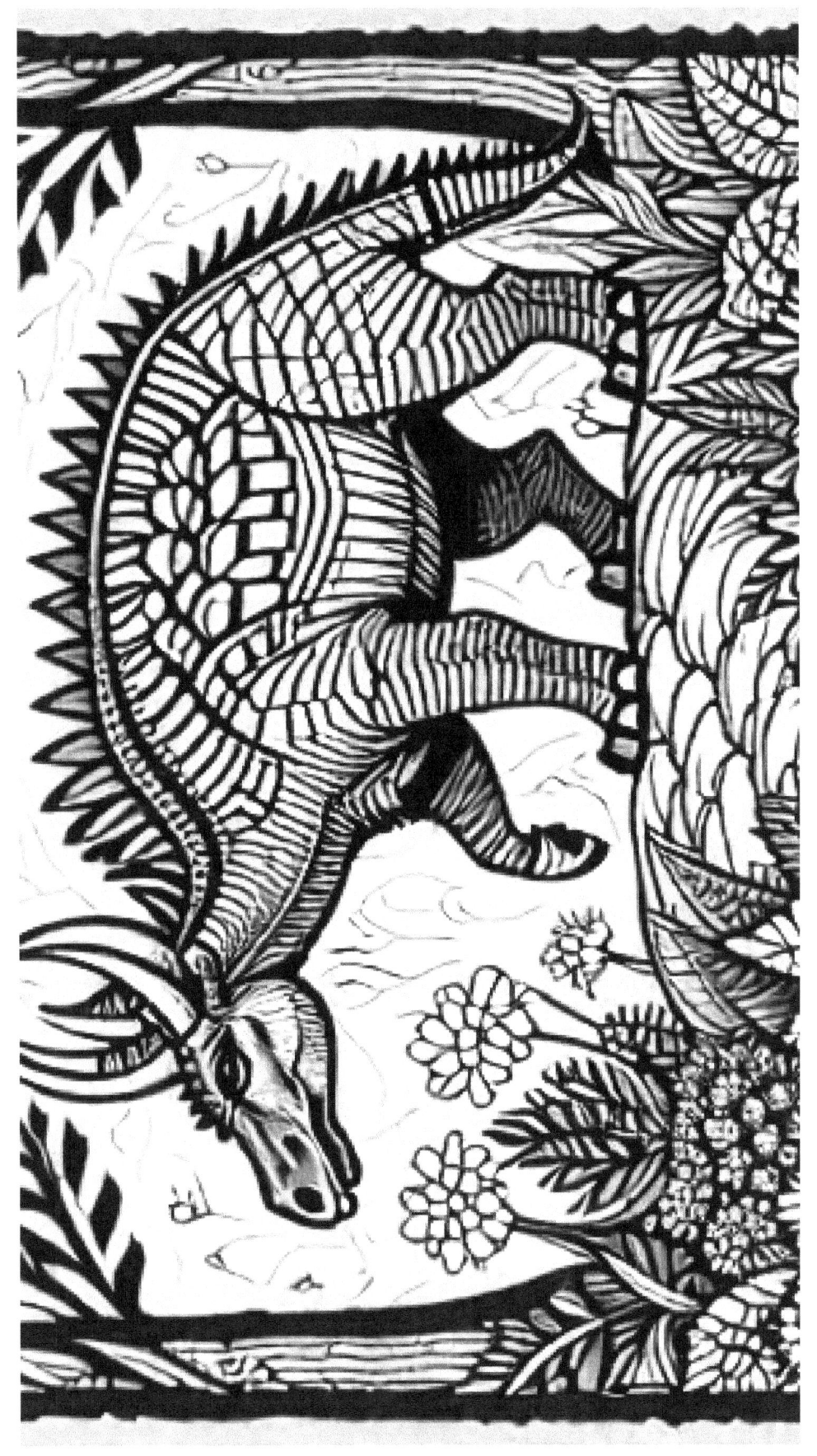

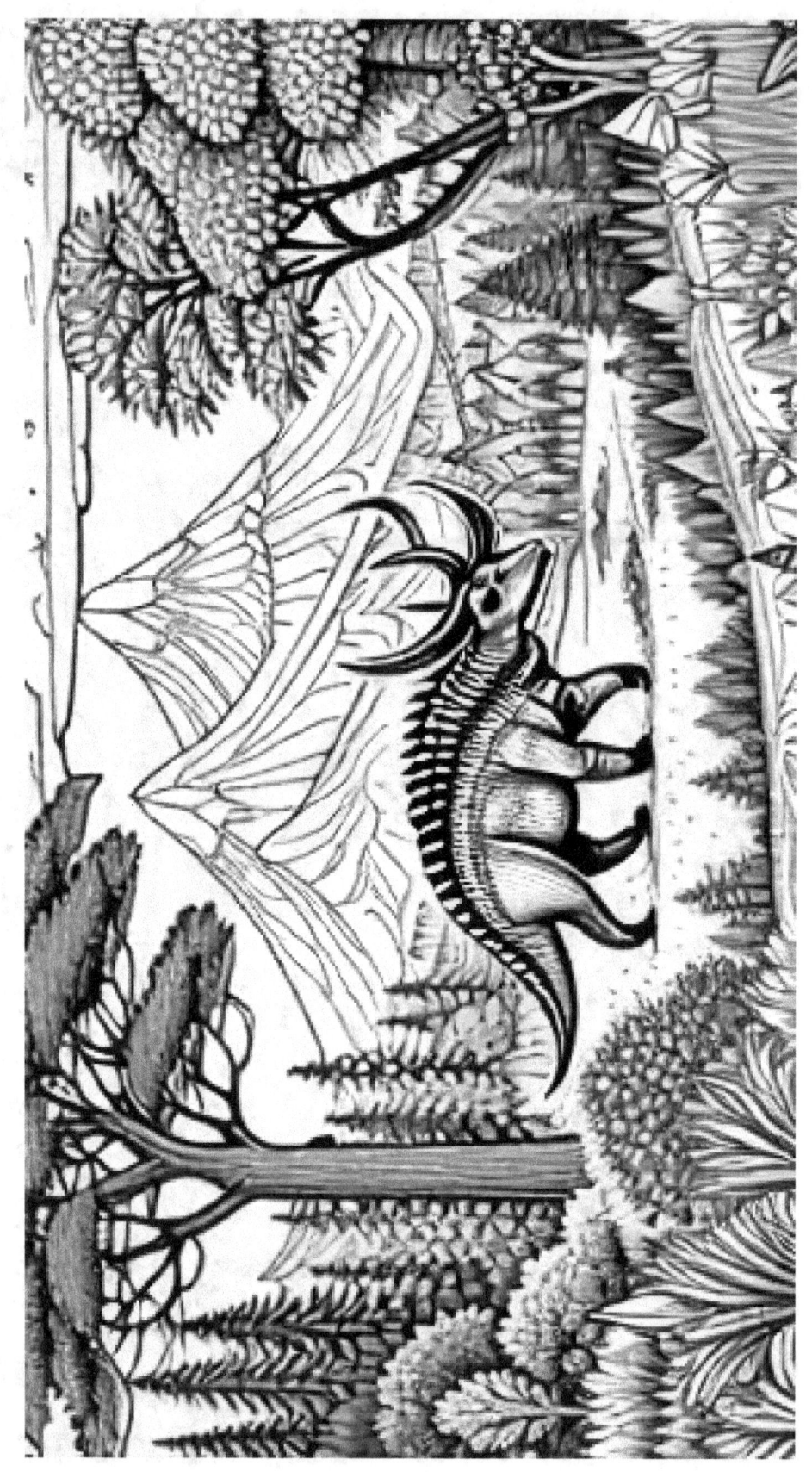

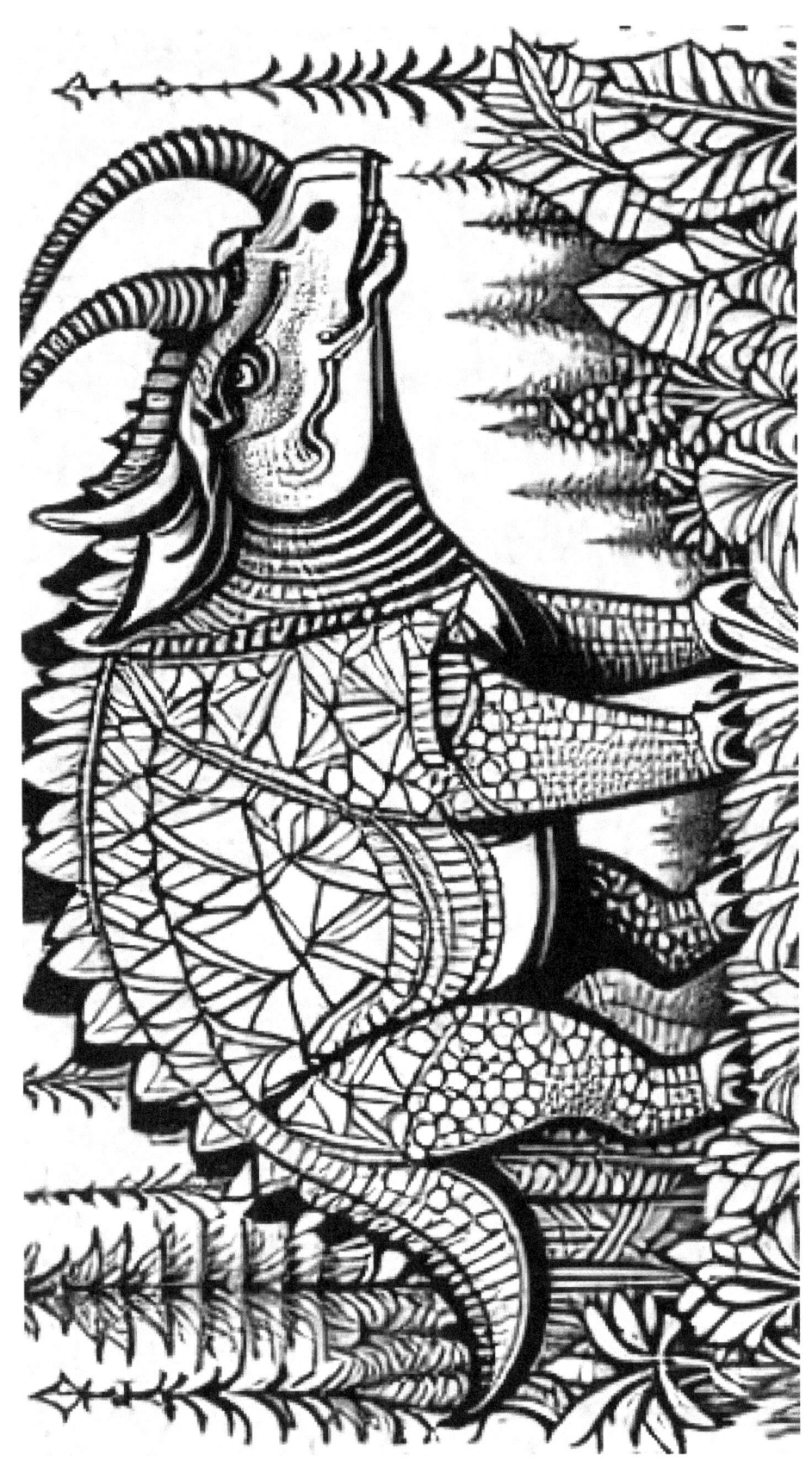

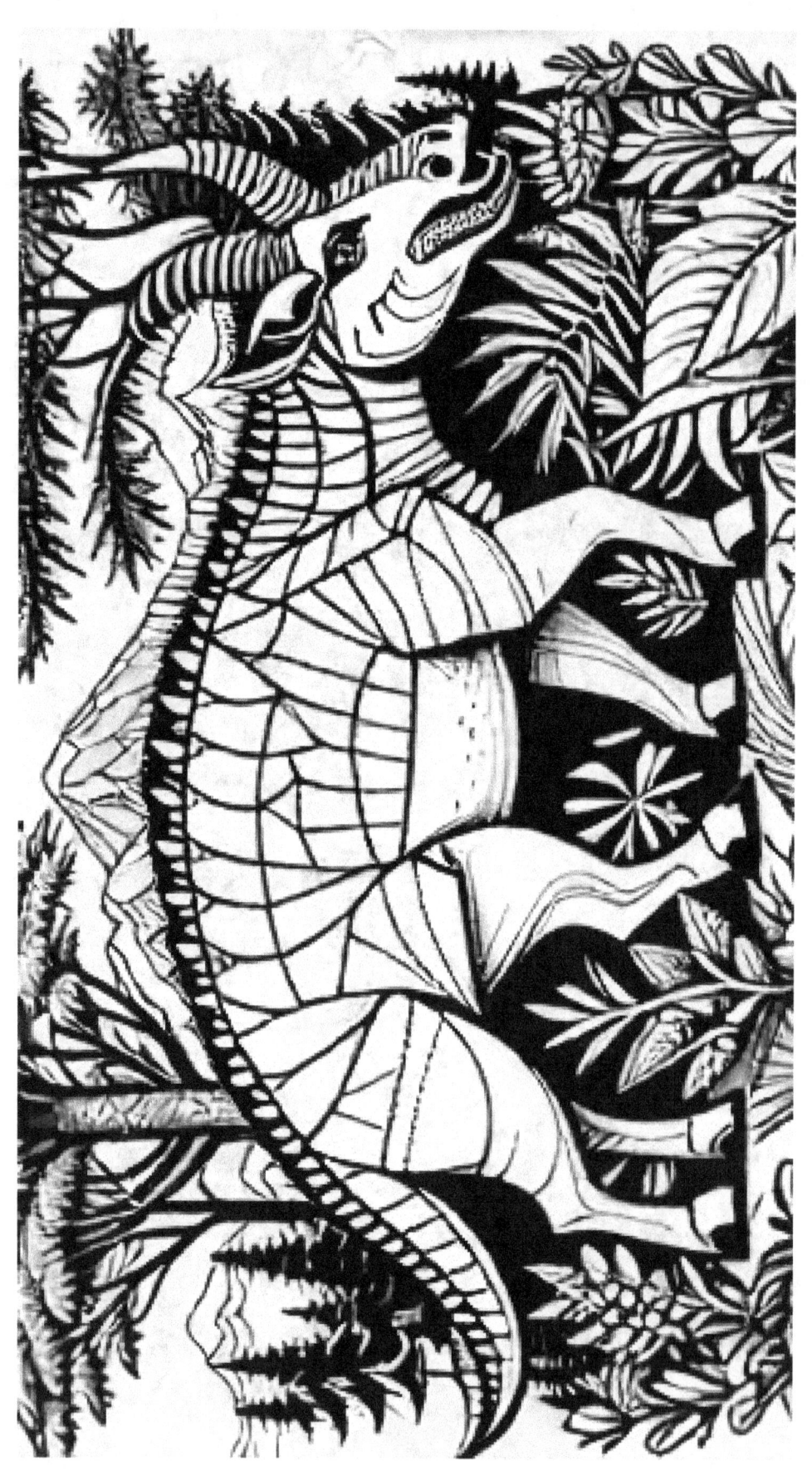

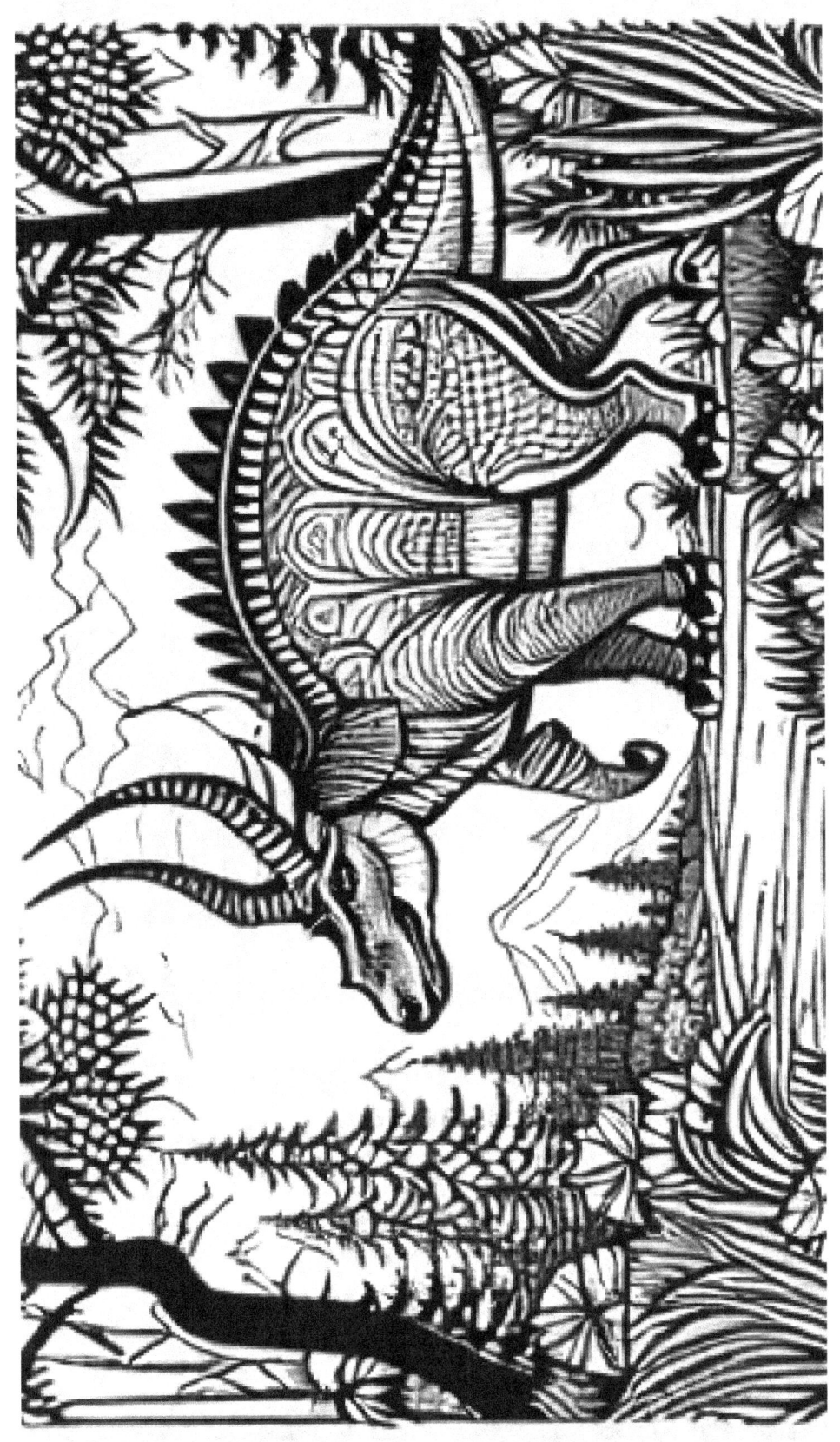

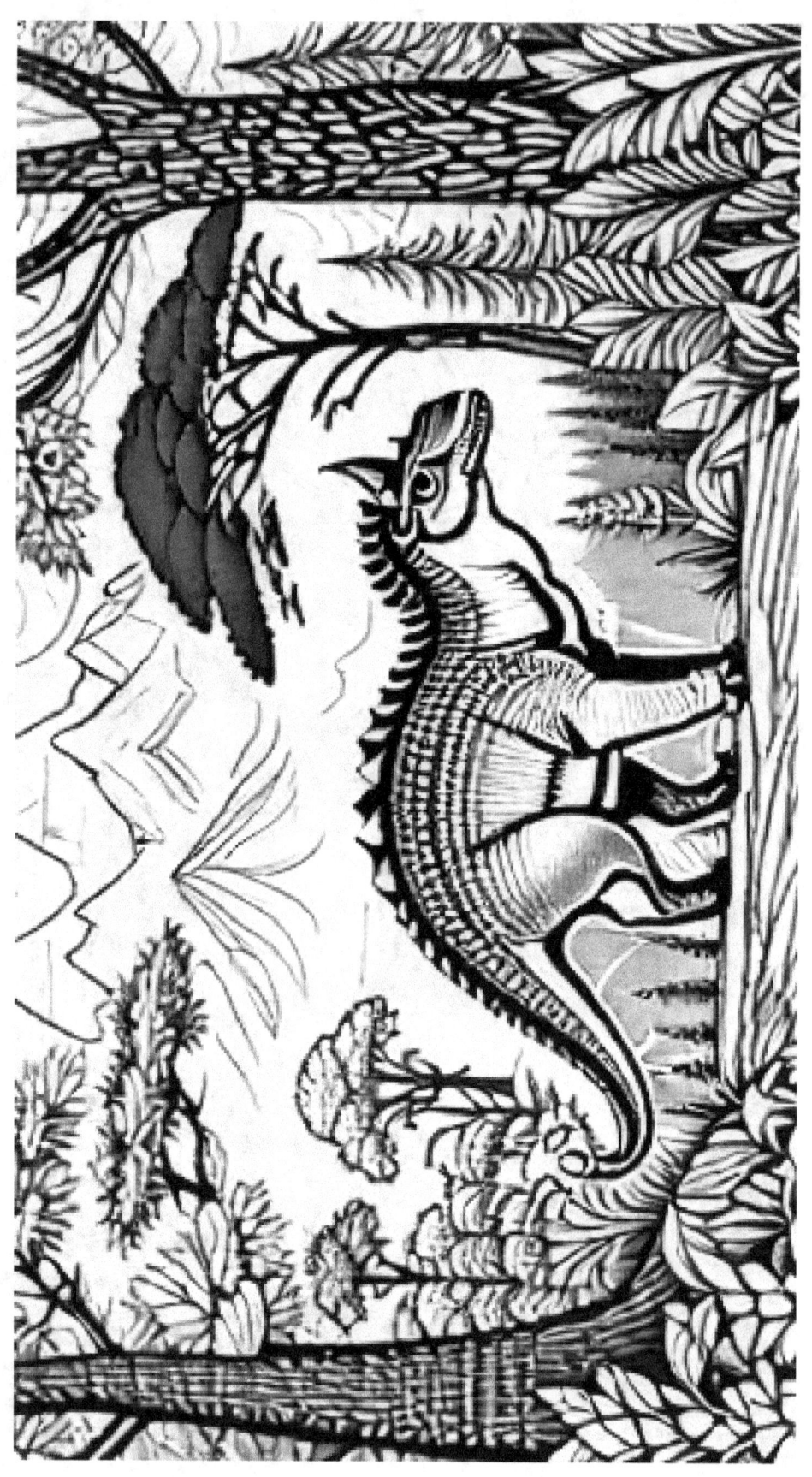

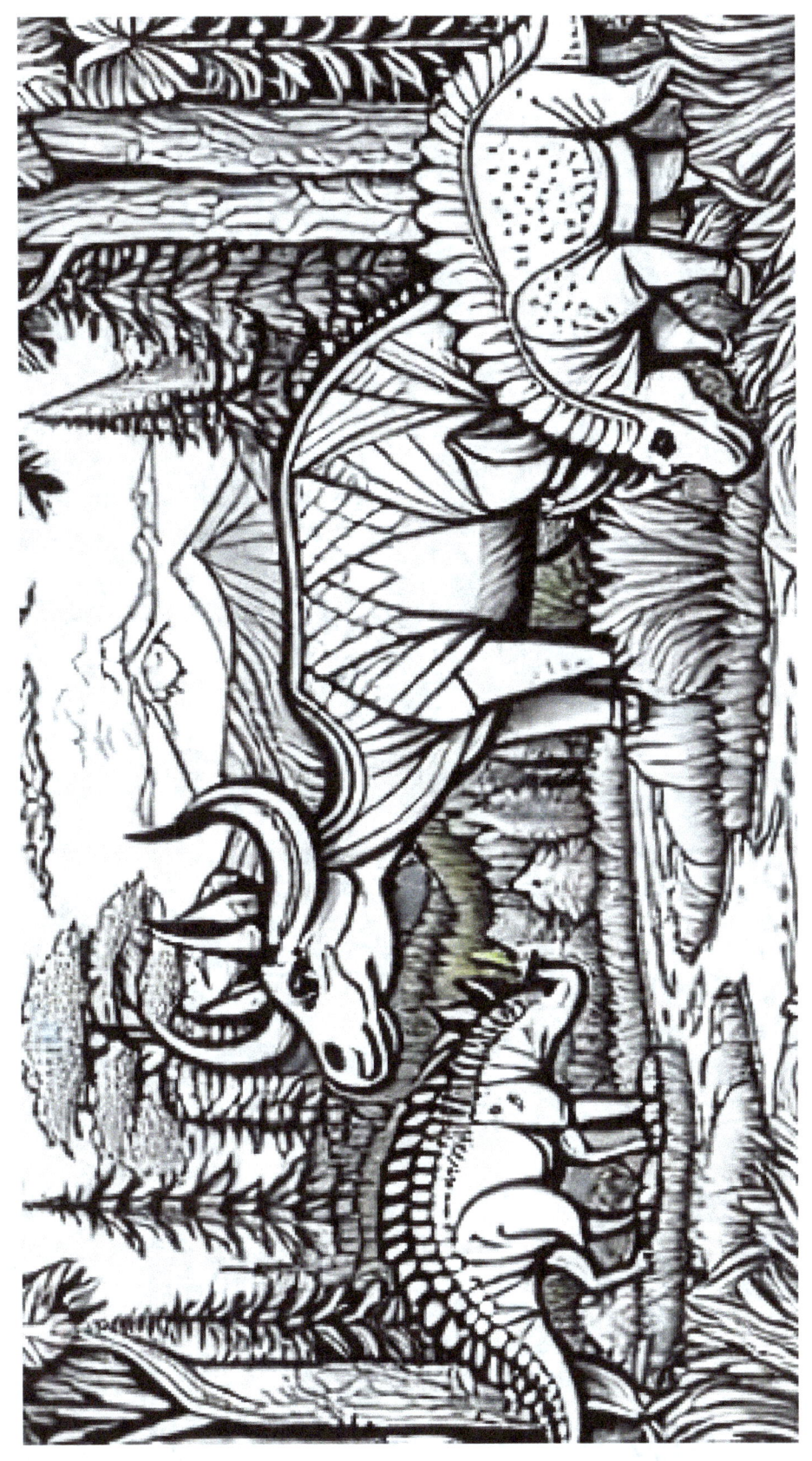

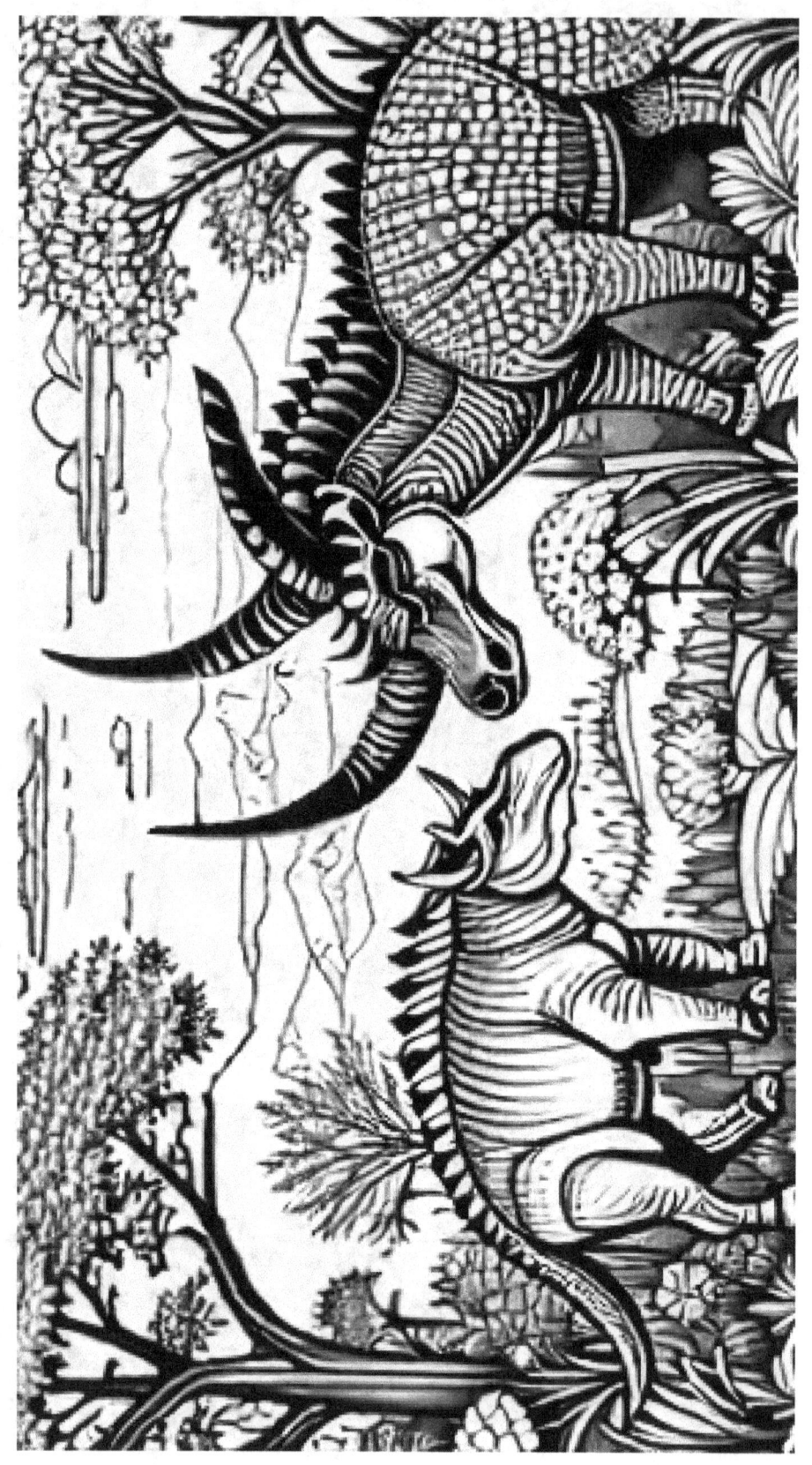

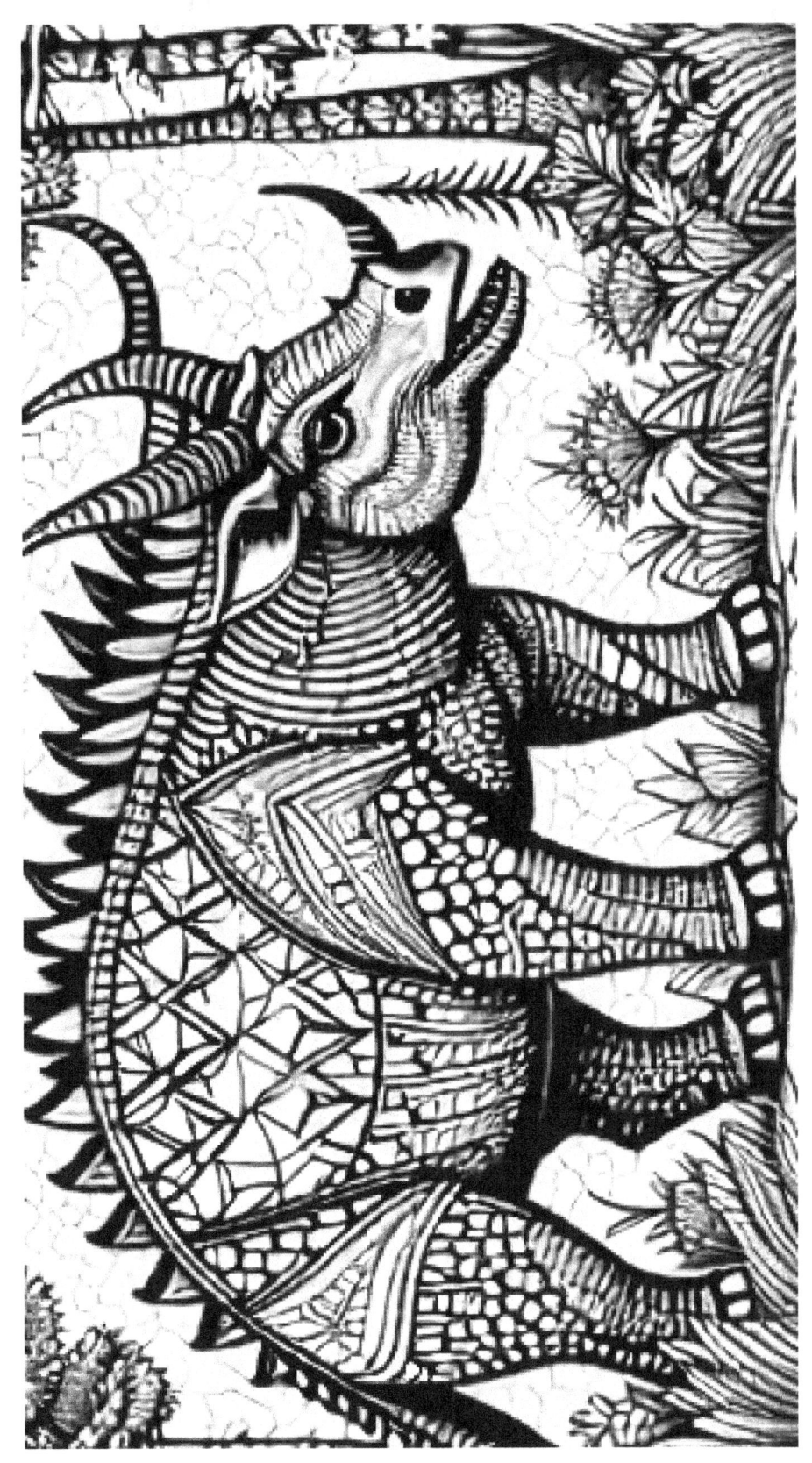

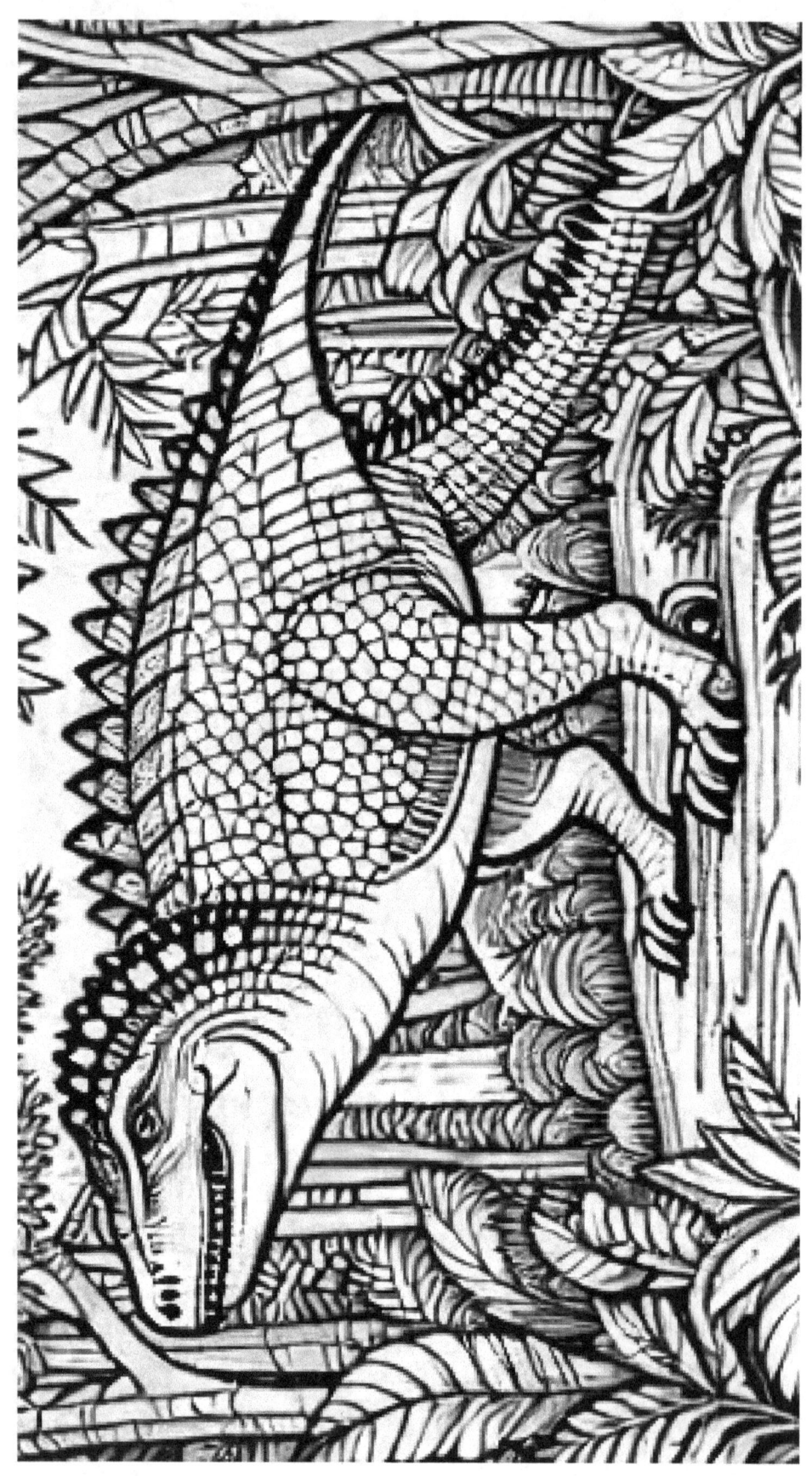

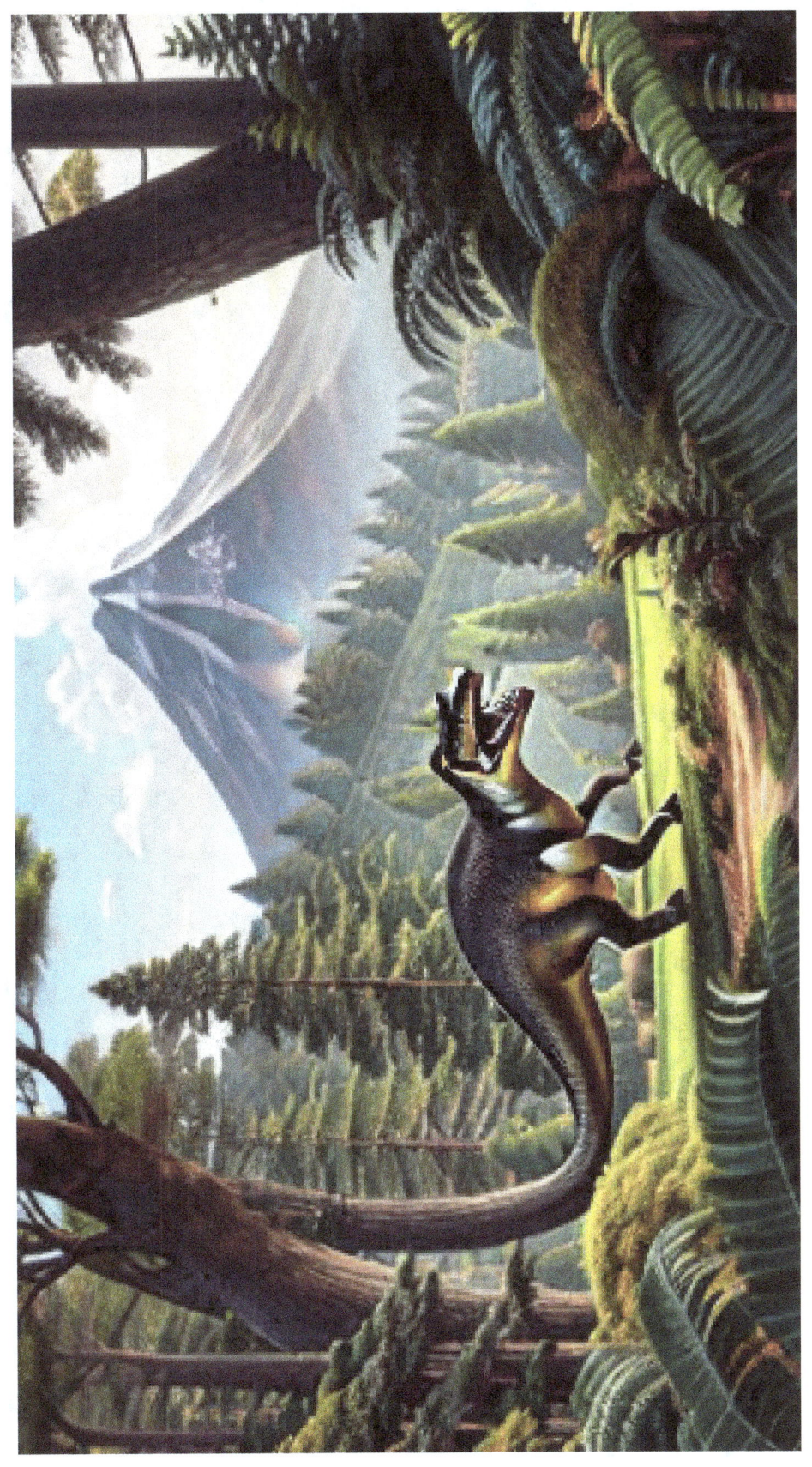

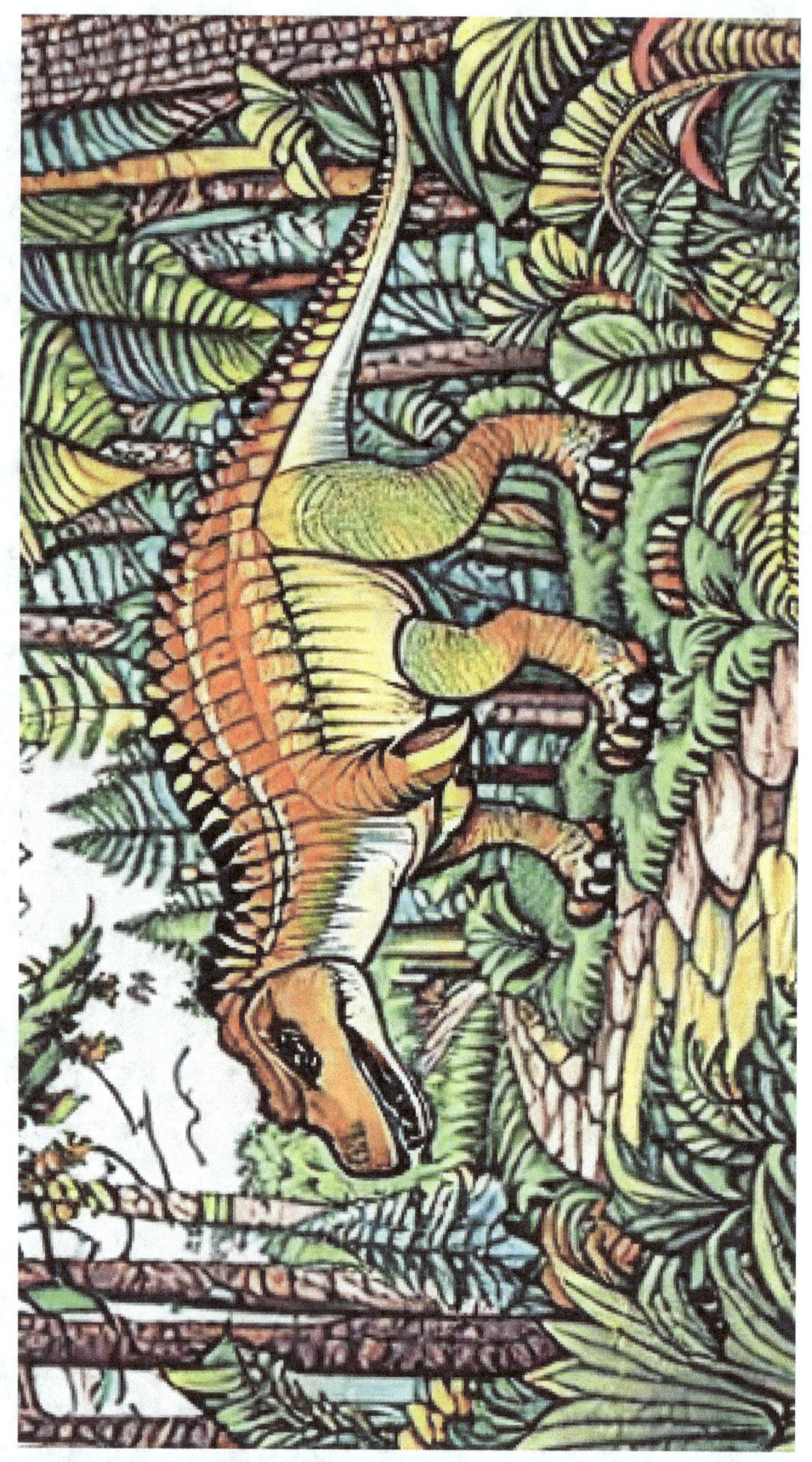

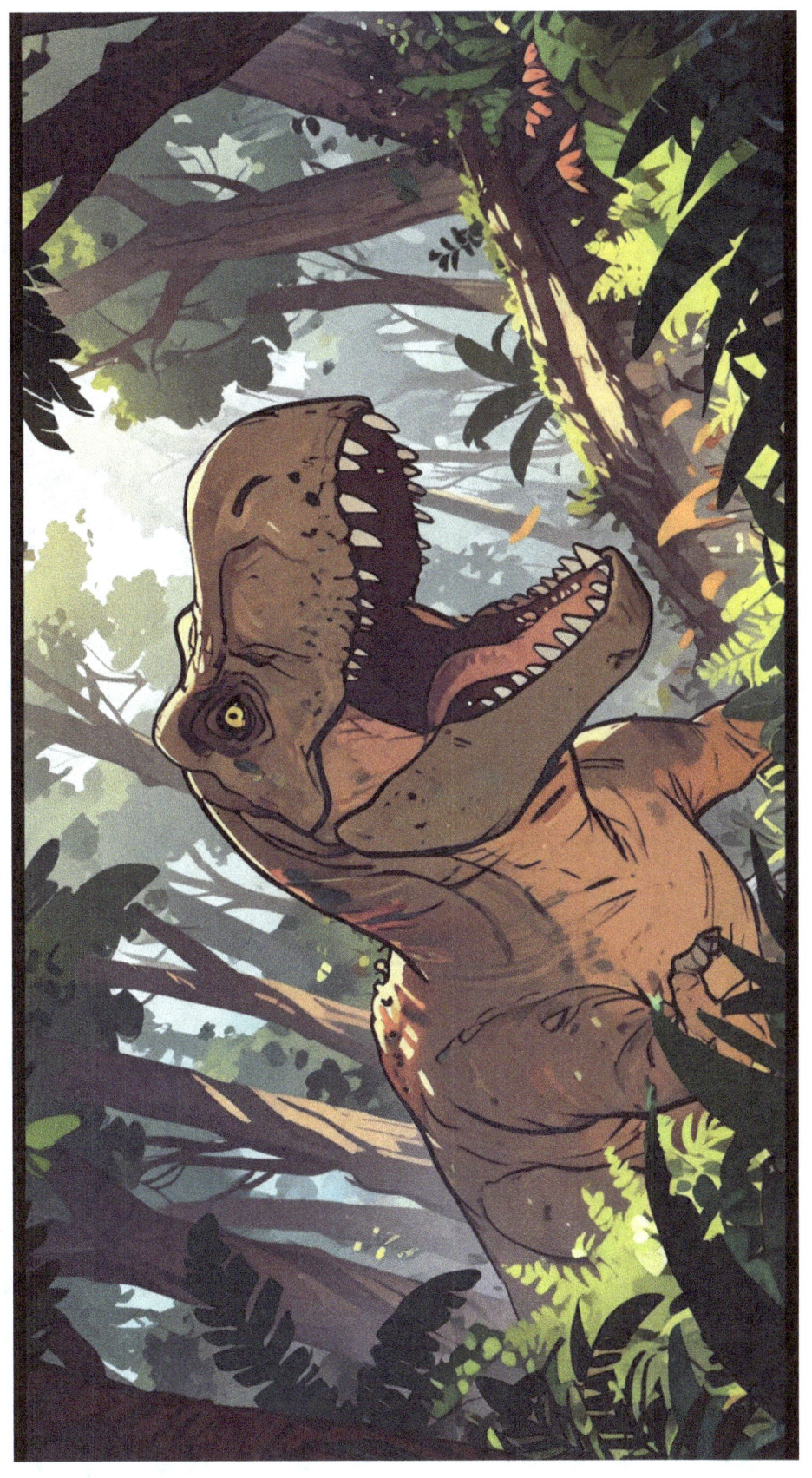

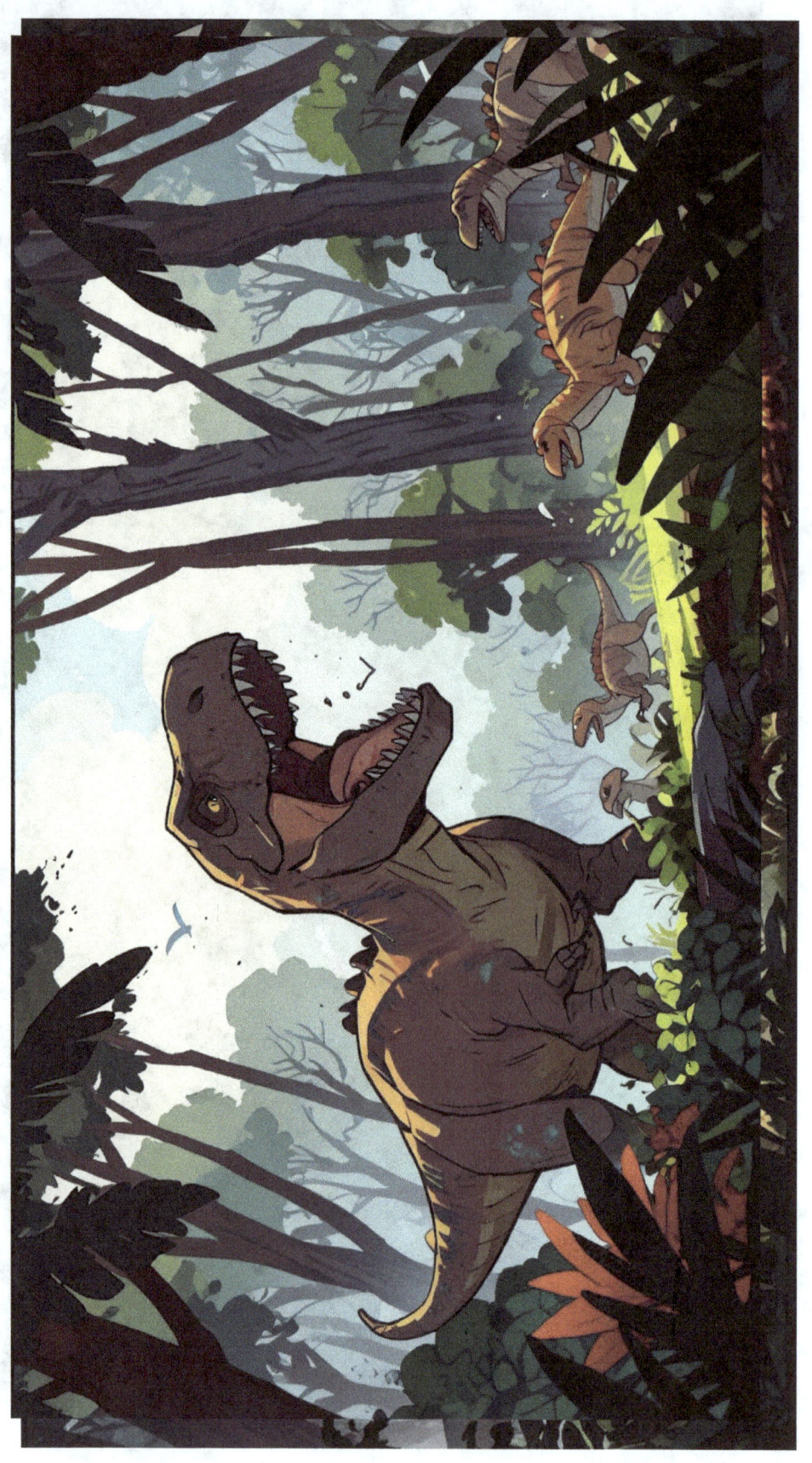

BIOGRAPHY OF THE AUTHOR

Full Name: Phan Xuan Hoa

Date of Birth: February 18, 1960

Place of Birth: Hanoi, Vietnam

Nationality: Vietnamese

Place of Work: Faculty of Sculpture, University of Arts - Hue University, 10 Tinh Tam, Thuan Loc, Hue City (1994-2020)

Education:

Bachelor of Fine Arts (Sculpture), Faculty of Sculpture, University of Arts - Hue University (1986 - 1994)

Work Experience:

Lecturer, Faculty of Sculpture, University of Arts - Hue University (1994-2020)

Vice Dean, Faculty of Sculpture (2008 - 2012), Faculty of Sculpture, University of Arts - Hue University

Dean, Faculty of Sculpture (2008 - 2012), Faculty of Sculpture, University of Arts - Hue University

Membership:

Member of Thua Thien Hue Fine Arts Association

Additional Notes:

Phan Xuan Hoa is a Vietnamese sculptor with over 30 years of experience teaching and creating art.

His work has been exhibited in Vietnam and internationally.

He is a respected member of the Vietnamese art community.

www.ingramcontent.com/pod-product-compliance
Lightning Source LLC
Chambersburg PA
CBHW082240220526
45479CB00005B/1285